THE JOHN H. MEIER, JR.

*Governor General's
Literary Award
for Fiction
Collection*

G000049286

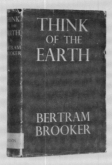

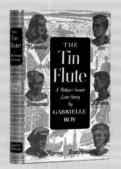

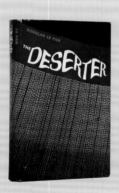

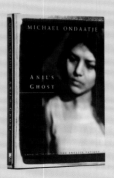

1936–2009

THE JOHN H. MEIER, JR.

Governor General's Literary Award for Fiction Collection

13 September 2010 to 14 January 2011
Bruce Peel Special Collections Library
University of Alberta

Bruce Peel Special Collections Library
B7 Rutherford South
Edmonton, Alberta, Canada
T6G 2J4

Copyright © University of Alberta Libraries 2010

From September to December, 2012, the Thomas Fisher Rare Book Library, at the University of Toronto, will host this exhibition; it will be accompanied by an updated edition of this catalogue.

LIBRARY AND ARCHIVES CANADA CATALOGUING IN PUBLICATION

Meier, John H., 1956-
 The John H. Meier, Jr. Governor General's Literary Award for Fiction Collection / John H. Meier ; editor, Linda Distad.

Includes glossary.
Exhibition catalogue of the author's collection of first editions of English-language works of fiction that have won the Governor General's Literary Award.
ISBN 978-1-55195-264-2

 1. Meier, John H., 1956- —Library—Catalogs. 2. Governor General's Literary Awards—Bibliography—Exhibitions. 3. Canadian fiction (English)—First editions—Bibliography—Exhibitions. I. Distad, Linda II. University of Alberta. Library III. Title.

PS8107.G6M45 2010 016.813'5 C2010-903506-2

Editor: Linda Distad
Book Design: Alan Brownoff
Photography: Ryan Mah
Exhibition Installation: Carol Irwin
Printed by McCallum Printing Group, Inc., Edmonton, Alberta.

For my Parents & Barclay C. Isherwood

Foreword

WHATEVER THE OBJECTS OF THEIR PURSUIT, all successful collectors display a degree of dedication that sometimes borders on obsession. The most successful, however, are those who commit their time, money, and passion, but also exhibit a laser-like focus and discipline. John H. Meier, Jr. is just such a collector. For more than a decade, this successful Vancouver entrepreneur has devoted himself to the study and collecting of the English-language fiction of his adopted country. By choosing to specialize, and collect the winners of the Governor General's Literary Award for Fiction, their first edition variants, proofs, and related documents, he has succeeded in amassing a collection of national significance, unmatched in depth and completeness even by Canada's national library collection. Meier's dogged research—ranging from publishers' archives to personal interviews— has unearthed and revealed the fascinating publishing history of those books generally acknowledged as the cream of English Canada's fiction output since the institution of the GG Awards in 1937. It is with both pride and pleasure that we at the University of Alberta Libraries are the first to play host to this remarkable exhibition of Canada's literary heritage.

ERNIE INGLES

Vice-Provost & Chief Librarian

Acknowledgements

I AM INDEBTED to the following organizations and individuals for their contributions to this project. A big thank you to the Bibliographical Society of America for a McCorison Fellowship and the Bibliographical Society of Canada for a Marie Tremaine Fellowship. These two grants came at a crucial time in the project and enabled me to complete my travel research in the United States and Canada. I also want to thank Carl Spadoni at McMaster University who encouraged me at the very beginning to expand my research. There are many people at the University of Alberta Libraries and the Bruce Peel Special Collections Library who made this first exhibit possible: Ernie Ingles, Merrill Distad, Jeannine Green, Carol Irwin, and Robert Desmarais. I especially want to thank Robert for his guidance, patience, friendship, and spearheading of all components of the catalogue. I wish to thank the following for their various contributions to this catalogue: Ryan Mah for the photography; William New for attaching a province to some of the authors; Linda Distad for her meticulous editing; and Alan Brownoff for the wonderful design.

THE JOHN H. MEIER, JR.

*Governor General's
Literary Award
for Fiction
Collection*

1936–2009

Introduction

THIS CATALOGUE PRESENTS examples of first editions of all the titles that have won Canada's prestigious Governor General's Literary Award for Fiction (GGS) from its inception to the present. If we look at the list as a whole, it soon becomes apparent that it represents most of the great Canadian authors of the twentieth century. When the Award was first given, very few books were being printed in Canada; many of the early winners were published in the United Kingdom and the United States. The first editions chosen for this exhibit are the editions that were originally distributed in Canada. In some cases, especially the early titles, the British or American edition was the only edition distributed in Canada. (I have added a few American and British editions for a design comparison.) This collection thus gives a fascinating perspective on the history of publishing and printing in Canada in the twentieth century.

I started this collection in late 1999 when, after almost 40 years of book collecting, chasing after the same literary high spots everyone else was pursuing, I began to think about uncharted areas of collecting that had been ignored or overlooked over the years. There are numerous literary awards in Canada: city, provincial, and national. During my research I came across the Governor General's Literary Awards. The Awards, founded in 1937, were initially administered by the Canadian Author's Association. I contacted the Canada Council for the Arts, a federal government organization that has been administering the Awards since 1959, to request a hardcopy of the cumulative list of winners. Upon reviewing it, I was surprised at how many winning titles I had read and enjoyed. However, many of the early titles had had decades to fall into obscurity, since they had not been reprinted.

Once I decided to collect the winners of the Governor General's Literary Award for Fiction, I became serious about purchasing the best copies available. I employ the same method when starting any collection. After a few months of research I can establish which titles are going to be the most difficult to locate. I then

concentrate on finding these first, since they will take the most time to locate. In the case of the GGs, it was the titles from the 1930s and 1940s that were going to be a challenge. Collecting really is a numbers game. The more time and energy you put into searching, the more likely it is you will find some great material.

I began by making two lengthy trips to Toronto. On one of these trips, over an eleven-day period, I visited every bookstore, big and small, in the city. I also took several road trips into the interior of British Columbia and Alberta to visit every little bookshop I came upon. I located some interesting material this way. For example, I found a copy of the long galleys for Robert Kroetsch's *The Studhorse Man* (1969) in Calgary (one of possibly three copies with textual differences). These galleys were produced from the original text of the author's manuscript. Kroetsch's editor suggested, and the author agreed, that the first three paragraphs in the galleys be omitted to improve the story. Instead of re-typesetting the entire novel at such a late date, the publisher removed the paragraphs and inserted the image used for the dust jacket cover on the first page of the novel.

On another occasion, I heard from a local bookseller that the remaining books in poet Al Purdy's collection had been bought by a rare book dealer in Victoria, BC. I immediately called the dealer and made arrangements to visit him the next day. I made the journey via BC Ferries early the next morning. This visit resulted in my purchase of half a dozen GG-winning titles inscribed to Purdy, who won two GGs himself for *Cariboo Horses* (1965) and *The Collected Poems of Al Purdy* (1986). In addition to his wonderful poetry, Purdy was a serious book collector who frequently asked fellow Canadian writers to inscribe his copies. One of the titles I bought that day, inscribed to the poet, was Alice Munro's first book of short stories, *Dance of the Happy Shades* (1968), in the first-issue dust jacket without the Award seal. There were only 2,675 copies printed of this, the first Ryerson Press edition. Another was the Lester & Orpen Dennys edition of Josef Škvorecký's *The Engineer of Human Souls* (1984), also inscribed to Purdy.

Association copies inscribed by one GG-winning author for another adds depth to the collection. Two great inscriptions in copies included in the exhibit are Dave Godfrey's *The New Ancestors* (1970) inscribed on the half-title: 'For Mrs. Jean Headon | Who made the library | which made me a writer. | Dave Godfrey | December, 1970,' and a copy of Margaret Atwood's *The Handmaid's Tale* (1985) inscribed to Gwendolyn MacEwen (two time GG winner for poetry) on the half-title: 'For Gwen | with all best wishes- | Peggy A.'

I had been told at the beginning, by several booksellers and collectors, that I would not be able to locate many of the early Canadian editions since they were printed in such small numbers. I've always enjoyed a challenge, so this only further motivated me to complete the collection. I was also helped by changes in how books were sold. In the past it was a challenge to build a large collection of important books. The most common method of collecting, until recently, was to befriend booksellers who specialized in one's area of interest. Additional ways to locate and buy rare and uncommon books included sending 'want lists' to various dealers, visiting used bookstores, attending book fairs, and requesting catalogues from dealers.

Over the past fifteen years the Internet has dramatically changed the way the general public and collectors buy books. The Internet turned out to be the perfect

tool for buying and selling books, which means dealers have almost entirely given up issuing catalogues. Numerous book-related websites sprung up in the early 1990s. I have also bought some great books on eBay. For example, I purchased my second copy of Bertram Brooker's *Think of the Earth* on eBay. Since I might be the only serious collector of the Governor General's Literary Award winners, I have had very little competition. I expect this to change.

In a matter of just a few years it seemed anyone could become a virtual bookseller. I believe there was a period of about four or five years when many incredible books were offered for sale. There was such an abundance of good books online that it appeared many were more common than was the case. It was too much of a good thing. Many collectors passed up opportunities to buy rare books, thinking that they could come back anytime to buy what they were looking for. Unfortunately, for some, those books are no longer easy to find.

There are advantages and disadvantages to having so many books online. One of the disadvantages is that if you purchase a book from someone you have not dealt with in the past, you may be very surprised by what you receive. Many would-be booksellers do not know how to grade a book's condition or even establish that it is a first edition, first printing. But then again, dealing with a novice bookseller you may just hit the jackpot! One of the advantages is that I have been able to purchase books from many places I would not have been easily able to contact by any other method. Thus I have purchased GG-winning titles from every province in Canada, a dozen US states, Switzerland, Britain, France, Australia, and New Zealand.

The objective from the start was simple: obtain the best copies available. This collection of fiction titles consists of over 500 volumes of first editions in fine condition. It also includes various issues of the American, British, Canadian, and Australian first trade editions, galleys, uncorrected proofs, trial dust jackets, advance review copies, association copies, author copies, letters, and ephemera. It was important to locate copies in their original dust jackets for several reasons. The first is that this was how the publisher originally meant the book to be presented to the public. The second is that in some cases the dust jacket will establish whether the copy is a first printing. The dust jacket art also represents changes in graphic design and marketing in Canada over an extended period.

By obtaining multiple copies of every title I have uncovered numerous binding variants. For example, during the Second World War there was a serious shortage of paper and binding material. In the process of binding a book, it was common to run out of cloth before completing the print run. So the bookbinder would complete the process by binding the remaining books in a material with a similar colour or texture. In most cases it is difficult to determine which colour or texture came first.

Several years into collecting the GGs I decided to write a descriptive bibliography of all English-language first editions, which would include a chronicle of the publishing history of the Awards. Library and Archives Canada (LAC, formerly the National Library) in Ottawa is missing many of the editions which are included in my collection. In addition, LAC's early policy was to discard the dust jackets on their copies. This meant the only way for me to document all of the English-language first editions was to collect them myself. To my knowledge, no comparable collection exists in public or private hands.

To add further depth to my collection, I have had some success in locating relatives of deceased authors. There is a lot of relevant material in their hands, just waiting to be found. Some of this may be authors' correspondence with their publishers, family copies of rare editions (possibly inscribed to a family member), and oral reminiscences from the author's family. This is when the skills of a detective become invaluable. Just tracking down a relative who may have a different surname can be an enormous challenge.

Every book collector has at least one or two 'holy grails' required to complete a collection. Mine, for this project, was the very first winner of the Governor General's Literary Award for Fiction: Bertram Brooker's *Think of the Earth*, published in Toronto in 1936 by Thomas Nelson & Sons, and in London by Jonathan Cape. After a couple of years of searching for this elusive title in bookstores and on the Internet, I decided to take a different approach. I gave myself twelve months to locate and purchase an important copy. Brooker's book had been recently reprinted for the first time. It dawned on me that the publisher of the reprint would have needed a first edition to reprint from, since there was only one initial printing for the Toronto and London editions. I contacted the publisher who did the reprint, only to be told that the editor for the book was no longer with the firm, and that she tracked down a copy, which they used to produce the new edition. Sounds simple. Unfortunately, the editor had gone through a divorce, changed her name, and moved to another province. Another three months of research helped me locate the editor through a professional organization she once belonged to. She put me in touch with the grandson of the author. Six months later, after dozens of telephone calls with the family, I acquired the author's reading copy of the book, with the author's notes on the rear endpaper highlighting certain passages. This copy is significant in that Brooker read from it at the first GG Awards ceremony, held at the University of Toronto's Convocation Hall on 24 November 1937. This was the best copy imaginable, other than the dedication copy.

The second phase of the project has involved writing a descriptive bibliography and tracking down publication data from 50 publishers. Over the past decade I have travelled for more than six months across Canada and the United States, conducting research at every major publisher's and author's archive related to the fiction list. This has also involved thousands of emails, many letters, and hundreds of telephone calls soliciting publication data. It has been a tremendous challenge to coax existing publishers to take the time to search their files and archives for publication data. I've also researched copyright records at the Library of Congress in Washington, DC, and the Canadian Intellectual Property Office in Gatineau, Quebec. I was able to piece together the publishing history of many titles through these records.

The third phase of the project was establishing a non-profit foundation to exhibit and tour the collection across Canada. I established the W.A. Deacon Literary Foundation (DLF) in April 2008. It is named in honour of William Arthur Deacon (1890-1977), Canadian literary critic and editor. Deacon championed many of these early authors at an important time in the development of our country's literary voice. It is in the spirit of Deacon that the DLF operates. In 2009 I was asked by colleagues from three eastern universities to provide a 'case study' on the Governor General's Literary Awards for the *Historical Perspectives on Canadian*

Publishing website. During my research that year my friend Dr Carl Spadoni, at McMaster University, located a private letter dated 1940 from William Arthur Deacon to Ellen Elliott of Macmillan Canada in the Macmillan archives. This letter has established that it was Deacon himself who came up with the idea of starting a national literary award. During the 1934–1935 period, Albert H. Robson, Toronto branch president of the Canadian Authors Association (CAA), queried Deacon for ideas on how to impress upon the public that books produced in Canada were high quality. By early 1937, final discussions took place between Dr Pelham Edgar, CAA national president, and the Governor General of Canada, Lord Tweedsmuir (John Buchan), himself an author. Tweedsmuir gave permission to use the name of the Governor General's office for the awards in perpetuity.

Initially the CAA, as agreed by the Governor General of Canada, controlled all aspects of the Awards, including jury selection. At first the judging was shared by the CAA and the Royal Society, a relationship that proved unworkable. Fellows of the Royal Society were choosing books that the public had no interest in, which consequently did not benefit the authors. The three CAA members, whose names were never announced publicly, controlled and built the early juries. They included William Arthur Deacon, Dr Pelham Edgar, and Leslie Gordon Barnard. In private, Deacon referred to himself and his two colleagues as the "supreme committee and supreme judges." The CAA's objective from the start was to aid the sale of Canadian literature.

Once the Canada Council for the Arts took over administration of the Awards in 1959, jury selection changed. The list of jury members chosen by the Canada Council, in both past and present, are some of the most respected authors and scholars residing in Canada. Many of the jurors were past recipients of the Award. As categories were added, the juries were expanded to meet the need. I challenge anyone who says that the GGs are insignificant since they are administered by a government body. Authors' peers and important Canadian scholars are choosing the winners!

There are some fascinating stories behind the publication of many of the winning titles. For example, Dr Philippe Panneton, a physician, academic, and diplomat, wrote *Thirty Acres* under the pseudonym Ringuet, his mother's family name. Originally published in French as *Trente Arpents* (Paris: Flammarion, 1938), it is an important novel of early Quebec life. Hugh MacLennan is quoted as saying that he could not have written *Two Solitudes* (1945) without having read *Thirty Acres*. There are two distinct Canadian editions of this title, both published in late 1940. Macmillan (Canada) initially ordered 500 sewn sheets from Macmillan (London) for the Canadian market. After great reviews were published, Macmillan (Canada) decided to re-typeset the novel and print 1,755 copies. The Canadian edition was printed by T.H. Best Printing Co. Ltd., Toronto.

Gwethalyn Graham's *Earth and High Heaven* (1944) has the distinction of being one of the first Canadian novels to achieve best-seller status in the United States. An important, timely novel about race relations, it was first published serially in *Collier's* (26 August–16 September 1944). The Literary Guild (club edition) and the trade edition, combined, sold 665,000 copies by late June 1945. I have identified seven trade edition printings. There were also two separate Jonathan Cape editions (printed in Toronto and London). The first printing of the J.B. Lippincott trade edition in a decent dust jacket is a scarce book.

Published to rave reviews, Hugh MacLennan's *Two Solitudes* (1945) was considered an instant classic. Its publication history is very complex. After the initial printing of 4,500 copies by The Vail-Ballou Press, all additional copies were printed by H. Wolff, New York. The American trade edition, Duell, Sloan and Pearce, published on 17 January 1945, preceded the Canadian edition, William Collins and Sons, that was released in April 1945. Most Canadians were introduced to this book through the American Book of the Month Club (BOMC) edition that was distributed only in Canada. This copy is the rare first trade edition, first printing, bound in dark grey cloth with a $3.00 price on the dust jacket. There are three binding variants of the trade edition: dark grey, deep blue, and dark reddish orange. The BOMC and trade publisher shared print runs. The dust jacket, designed by Lisbeth Lofgren, was inspired by a vintage photograph of the Chateau Frontenac Hotel above the houses of Quebec's Lower Town. The production standards for the British edition were inferior to the American and Canadian editions. The materials used for the binding and paper are very poor. On all copies I have inspected, the publisher has misspelled the author's surname on the binding's spine, omitting the "a" in "Mac." The British edition was published in 1945, but bears a 1946 date on the title page.

Gabrielle Roy is considered by many to be one of the most important Francophone writers in Canadian literature. There are two French versions of *Bonheur d'occasion* (Second-hand Happiness), later translated as *The Tin Flute*. The first was published in 1945 by Société des Éditions Pascal in two volumes. In 1965, Librairie Beauchemin published an abridged French version. The original French version won the prestigious Prix Femina in 1947. The Reynal & Hitchcock edition of *The Tin Flute* (1947) was translated by Hannah Josephson. This, Roy's first novel, gave a starkly realistic portrait of the lives of people in Saint-Henri, a working-class neighbourhood of Montreal. This edition was distributed in the United States and Canada, where it sold more than 600,000 copies. It was a Literary Guild of America selection for May 1947. That same year, Roy became the first woman admitted to the Royal Society of Canada. The McClelland and Stewart edition was printed (5,000 copies) after that publisher had ordered and sold 12,500 copies of the Reynal & Hitchcock edition.

David Harry Walker is the only recipient to have won the Award in two consecutive years. His first win was for *The Pillar* (1952), a war novel influenced by his experiences in the military. The Canadian and British edition was published by Collins (London) in a single printing of 25,000 copies. There was also an American edition (three printings) published that same year by Houghton Mifflin. The following year his comic novel *Digby* (1953) was published, which also won the Award. Again the book was published by Collins (London), this time in two printings of 20,000 and 8,000 copies. Houghton Mifflin published the American edition in a single printing of 6,270 copies.

The next year, one of the GG jurors, Claude T. Bissell, then vice-president of the University of Toronto, quit over the decision to give the Award to Igor Gouzenko. (Gouzenko was a Russian cipher clerk at the Soviet Embassy in Ottawa, who defected with about 100 telegrams and other classified documents he'd stolen from a consular safe, exposing an extensive espionage ring operating in North America and Britain at the end of the Second World War. He has been credited

with launching the Cold War.) In a letter to W.A. Deacon, editor at the *Globe & Mail*, Bissell said he did not consider *The Fall of a Titan* (1954) to be a serious contender for the Award. He felt the best novel that year was *Leaven of Malice* by Robertson Davies: "*The Fall of a Titan* was, admittedly, a potent pot-pourri of journalism and politics with some skilful literary echoes. It was not, by any standards, a good novel, and I am convinced that future historians will look upon it as a literary curiosity." It appeared Gouzenko was being rewarded for his defection and not his literary talent. It was also published in the United States the same year by W.W. Norton & Company and became a Book of the Month Club selection. Gouzenko, who was also an artist, embellished many copies of his novel with drawings or sketches on the front free endpapers.

The Canada Council for the Arts, soon after taking over administration of the Awards, began commissioning special presentation copies. The Queen's Printer notified Douglas LePan on 17 March 1965 that he had won the Governor General's Literary Award for his novel *The Deserter* (1964). The Governor General, Georges Vanier, gave a special presentation copy, an art binding (reliure d'art), to the author at a ceremony at Rideau Hall on 26 April 1965. This copy was rebound by Louis Forest in full leather with a red and gilt design on the front and rear covers, with ornate gilt tooling. Beginning in 1973, master bookbinder Pierre Ouvrard was commissioned to create an art binding for each of the winning titles for presentation to the authors. Ouvrard produced more than 300 original bindings for the Awards until his retirement in 2004. In 2005, Lise Dubois took over, producing her own unique presentation bindings.

Margaret Laurence, best known for *The Stone Angel* (1964), the first in the five-volume Manawaka series, is one of our country's most beloved authors. Although she didn't win a GG Award for this novel, she did win the first of two GGs for *A Jest of God* (1966). The text of the McClelland and Stewart edition of it was offset from the Macmillan (UK) edition. The book was printed simultaneously in cloth (2,000 copies) and paper (7,740 copies). There are two issues of the cloth edition. The first issue, in sewn signatures, measures 20.4 x 13.1 cm, while the second issue, perfect bound, measures 19.8 x 12.8 cm. It appears that a small portion of the soft cover issue was bound (possibly rebound) in hard covers to meet the demand for cloth-bound copies. The paper used for the first edition is very acidic, thus it has become difficult to locate collectable copies today. The dust jacket design for the M&S edition is a modified version of the Warren Chappell design for the Alfred A. Knopf edition, which was a larger format.

The publication history of Alice Munro's *Who Do You Think You Are?* (1978) is part of Canadian literary legend. In an interview with Carole Gerson, published in *Room of One's Own* (vol. 4, no. 4, 1979: 2–7), Munro explained the publication history of the book. Her agent had submitted the collection of stories to Knopf, her American publisher, and Macmillan Canada in the spring. They both agreed to publish the collection. However, they thought the stories were about the same character and suggested she write more stories to complete the book. The American publisher was willing to wait, but Macmillan wanted to publish that fall. Munro corrected Macmillan galleys in September. Meanwhile, she was writing additional stories for the American publisher. After completing two more stories and incorporating them into the manuscript for the American book, she

realized she had a much stronger book about one person. She then approached Macmillan about the changes. They said the book couldn't be changed at such a late date. "I kept arguing that it had to be changed. Eventually they called the production manager in and said that it could be taken off the press and be completely reset, hiring overtime people, at a cost to me of about $2500 which my contract said I had to meet if there were changes this late. So I said okay. I think it was the right thing to do." It was published in the United States by Alfred A. Knopf (1979) and the United Kingdom by Allen Lane (1980) under the revised title *The Beggar Maid*.

Sometimes publication was affected by an editor's demands. George Bowering had initially sent the manuscript of *The Dead Sailors* (working title) to his regular publisher, McClelland and Stewart, as a previous contract required. His editor at M&S felt the novel needed significant rewriting. Bowering later offered the manuscript to Julie Beddoes, senior editor at General Publishing, because of the association with Robert Kroetsch, who Bowering felt had the same attitude toward "history." The manuscript for *Burning Water* (1980, final title) was handwritten in three bound notebooks purchased in Vancouver's Chinatown. Bowering had initially requested that General reproduce the ship logos from the notebooks on the novel's endpapers. Ultimately the publisher reproduced the logo of a sailing ship at the first chapter. This is a difficult title to locate in collectable condition because of the fragile gold foil dust jacket.

Several titles that have won the Award were the author's first book. Nino Ricci wrote his first novel, *Lives of the Saints* (1990), for his M.A. in Creative Writing at Concordia University. Gary Geddes of Cormorant Books offered to publish it, but recommended that Ricci first try a larger commercial house. After several large publishing houses turned it down, Ricci signed a contract with Cormorant. A month or two after the contract was signed, Ricci met Peter Day of Allison & Busby (W.H. Allen) at the PEN conference in Toronto. Day took the manuscript with him and read it on the plane; before setting down at Heathrow, he was determined to publish the book and proceeded to buy U.K. and Commonwealth rights. The Cormorant edition was published simultaneously in cloth (400 copies) and paper (1,514 copies). The title for the Alfred A. Knopf edition, published the following year (1991), was changed to *The Book of Saints*. This work is the first volume in a trilogy.

In addition to books, I have collected GG authors' letters discussing their award-winning book. These include two Hugh MacLennan letters, addressed to a New York author, discussing *Two Solitudes* a month in advance of publication; a Gabrielle Roy letter discussing *The Tin Flute*; a Germaine Guevremont letter discussing her background and hunting birds in *The Outlander*; an Igor Gouzenko letter addressed to the Chairman of the Governor General's Awards Board thanking him for choosing *The Fall of a Titan*; and a Margaret Laurence letter addressed to a musician at her church in Lakefield, Ontario, laid into an inscribed copy of *The Diviners*.

Throughout the years this project has been a labour of love. I have spent thousands of hours locating and purchasing the best copies available. The most exhilarating part was finding that elusive book I had been seeking for years. Today I am still excited to obtain an edition that I have never seen before, an association

copy, or a rare advance state. It is difficult to stop, for there is always something else to add to the collection. It is difficult to explain the tactile pleasure of holding some of this rare material in my hands. Whether it is an inscribed book, a personal letter, or some other literary material that the author has handled, it is very exciting. I feel both privileged and grateful to have had the opportunity to own and examine this material.

Now I would like to share some of that excitement with others, particularly the many immigrants who came to this country for a better life. Many of them, like me, have not had the opportunity to study Canadian history in school. Over the past decade I have read the majority of the winning fiction titles. That reading has given me a physical connection with Canada. The historical novels, the novels of the immigrant's experience, and others have provided me with an education about my adopted home.

Nonetheless, I have asked myself, on several occasions over the past decade, whether I was committing financial suicide by investing my life's savings, and over a decade of my time, to build this collection. I am convinced that I made the right decision, because the Governor General's Literary Award for Fiction is so important to Canada's culture, even though other awards have also had an impact. Several other awards have actually changed our perspective on Canadian literature. Ironically, it has taken literary awards, outside Canada, to draw attention to our writers and their work. The Man Booker Prize is one of these. Several major Canadian works have won the Booker, including Michael Ondaatje's *The English Patient* (1992, also a GG winner); Margaret Atwood's *The Blind Assassin* (2000); and Yann Martel's *The Life of Pi* (2001). Carol Shields won the Pulitzer Prize for *The Stone Diaries* (1993, also a GG winner). I believe Mordecai Richler's statement to be true: "Actually, when it comes to knocking the Canadian cultural scene, nobody outdoes Canadians, myself included. We are veritable masters of self-deprecation."

We seem to have an inferiority complex about the quality of our literature. This may simply be the result of living in such close proximity to the 10,000 pound elephant which is the United States. We are constantly being bombarded by American culture in print and film, which overshadows our own literary voice. This makes the Governor General's Literary Award for Fiction especially important. It is my hope and desire that exhibiting highlights from my collection will educate and excite the public about our outstanding literary history.

JOHN H. MEIER, JR.
Delta, British Columbia

www.deaconfoundation.com

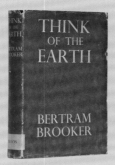

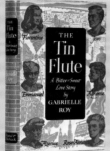

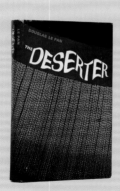

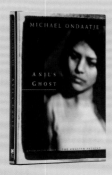

1936–2009

THE JOHN H. MEIER, JR.

Governor General's Literary Award for Fiction Collection

[MANITOBA]

Brooker, Bertram

Think of the Earth

Toronto: Thomas Nelson and Sons, 1936
Published June 1936 @ 7/6 (Britain) $2.00 (Canada)
Printed by J. and J. Gray, Edinburgh, Great Britain
Author's Reading Copy

Author's reading notes on rear free endpaper >

1936

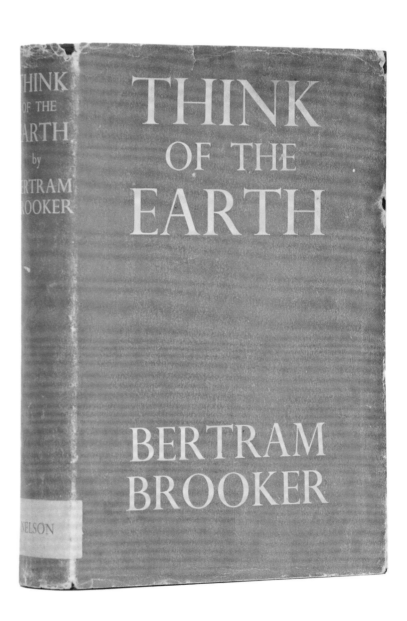

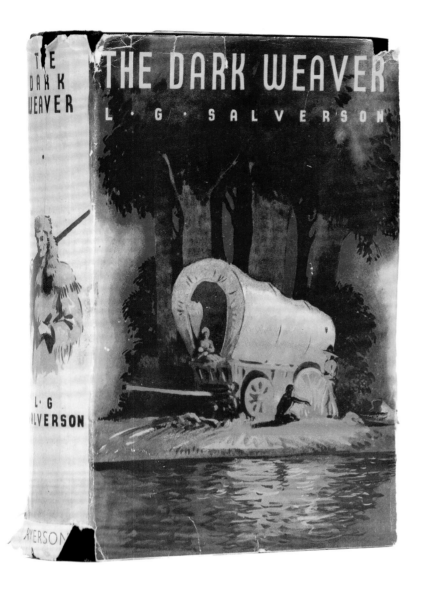

[MANITOBA]

Salverson, Laura Goodman

The Dark Weaver

Toronto: The Ryerson Press, 1937

Published November 1937 @ $2.00

Printed by the Star and Gazette Limited,
 Guernsey, Channel Islands

[QUEBEC]

Graham, Gwethalyn (Erichsen-Brown)

Swiss Sonata

New York: Charles Scribner's Sons, 1938
Published 8 April 1938 @ $2.50
Printed by Robert Teller Sons & Dorner, New York

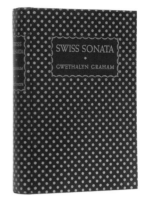

Binding without dust jacket >

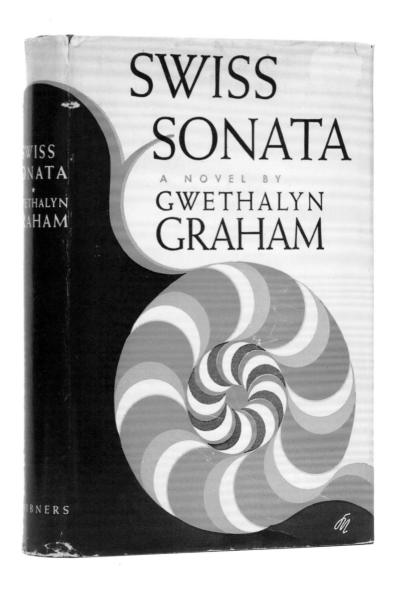

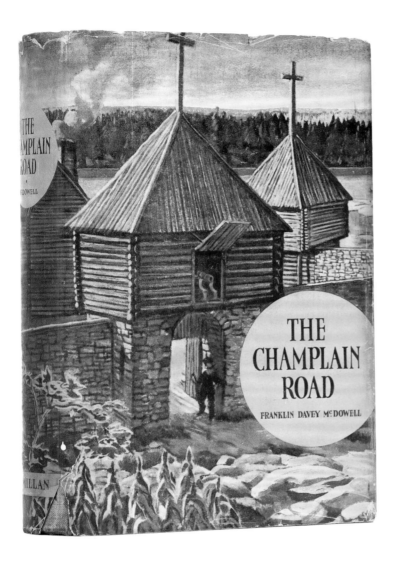

[ONTARIO]

McDowell, Franklin Davey

The Champlain Road

Toronto: The Macmillan Company of Canada Limited, 1939
Published 6 November 1939 @ $2.50
Printed by Armac Press Ltd., Toronto
Author's copy

[QUEBEC]

Ringuet (pseudonym), Panneton, Philippe

Thirty Acres

Translated by Felix and Dorothea Walter

Toronto: The Macmillan Company of Canada Limited, 1940

Published 15 November 1940 @ 7/6 (Britain) $2.50 (Canada)

Printed by Lowe and Brydone Printers Limited, London

Review Copy

1940

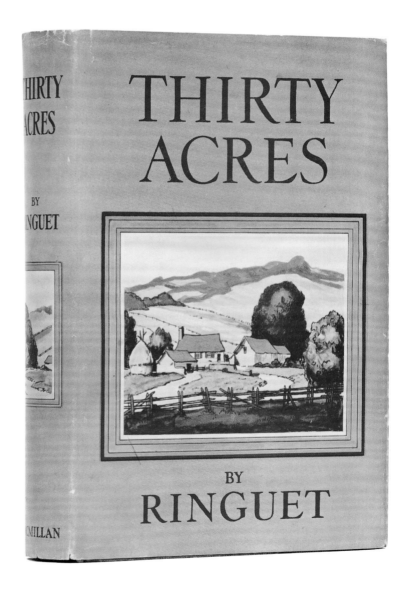

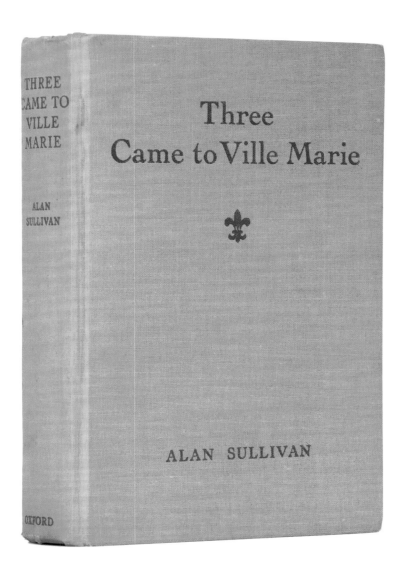

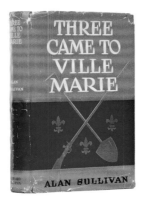

[ONTARIO]

Sullivan, Alan (Edward)

Three Came to Ville Marie

Toronto: Oxford University Press, 1941
Published 29 November 1941 @ $2.50
Printed in Canada
Without dust jacket

< *Three Came to Ville Marie*
New York: Coward-McCann, Inc., 1943
Published 18 January 1943 @ $2.50
Printed by The Cornwall Press, Cornwall, New York

[ONTARIO]

Sallans, G. Herbert

Little Man

Toronto: The Ryerson Press, 1942
Published 18 November 1942 @ $3.00
Printed by The Ryerson Press, Toronto
Signed

1942

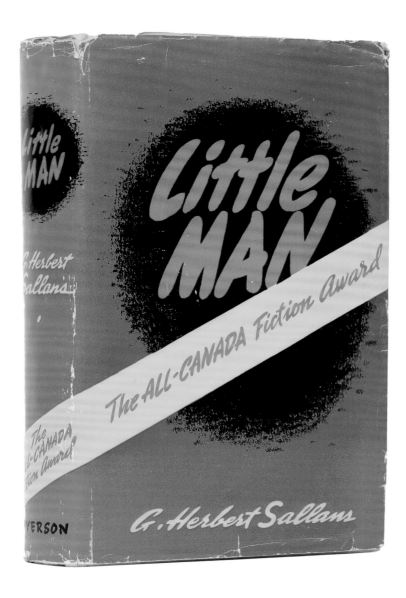

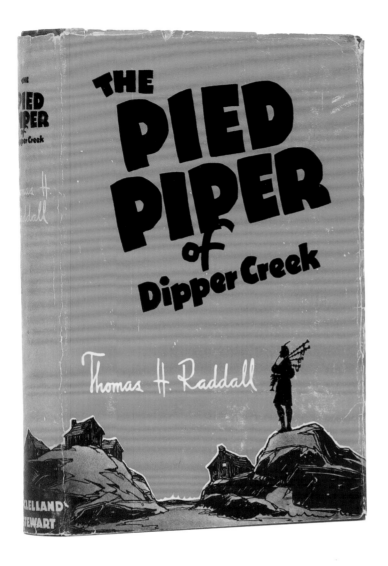

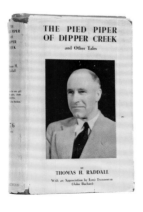

[NOVA SCOTIA]

Raddall, Thomas H.

The Pied Piper of Dipper Creek

With an appreciation by Lord Tweedsmuir (John Buchan)
Toronto: McClelland and Stewart Publishers, 1943
Published October 1943 @ $2.50
Printed by the Hugh Heaton Printing House Limited, Canada

< *The Pied Piper of Dipper Creek*
With an appreciation by Lord Tweedsmuir (John Buchan)
Edinburgh and London: William Blackwood & Sons Ltd., 1939
Published December 1939 @ 7/6
Printed by William Blackwood & Sons Ltd., Great Britain

[QUEBEC]

Graham, Gwethalyn (Erichsen-Brown)

Earth and High Heaven

Philadelphia & New York: J.B. Lippincott Company, 1944

Published 31 August 1944 @ $2.50

Printed by The Vail-Ballou Press Inc., Binghamton, New York

1944

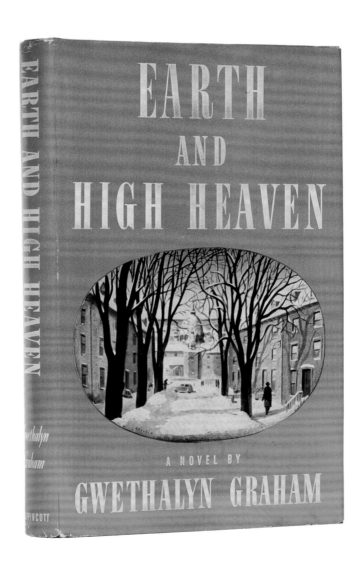

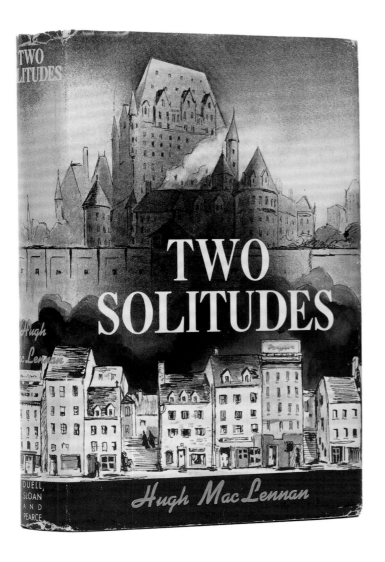

[NOVA SCOTIA]

MacLennan, Hugh

Two Solitudes

New York: Duell, Sloan and Pearce, 1945
Published 17 January 1945 @ $3.00
Printed by The Vail-Ballou Press, Inc., Binghamton, New York
Jacket design: Lisbeth Lofgren

< *Three binding variants of the Duell, Sloan and Pearce trade
edition: dark grey, deep blue, and dark reddish orange*

Two Solitudes
London: Cresset Press, 1946
Published in late 1945 @ 10/6
Printed by Latimer, Trend & Co., Ltd., Plymouth, Great Britain
Signed

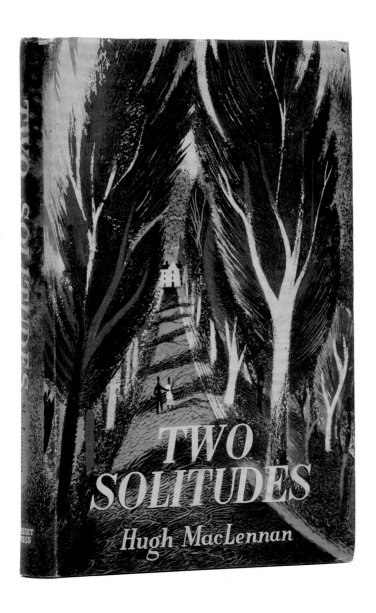

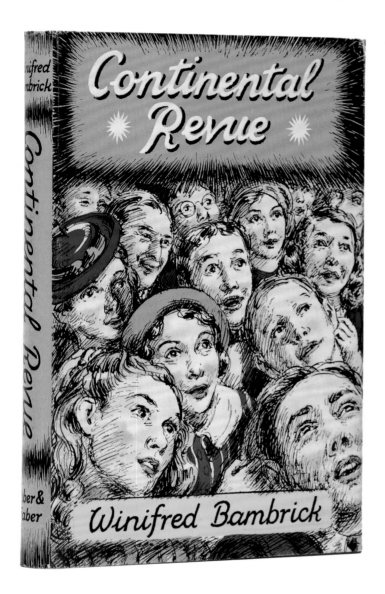

[ONTARIO]

Bambrick, Winifred (Estelle Geraldine)

Continental Revue

London: Faber and Faber Ltd., 1946

Published 4 October 1946 @ 9/6 (Britain) $2.50 (Canada)

Printed by Purnell and Sons Limited, Paulton (Somerset)
 and London

Published in the United States the same year under
 the revised title *Keller's Continental Revue* by
 Houghton Mifflin

[MANITOBA]

Roy, Gabrielle

The Tin Flute

Translated by Hannah Josephson

New York: Reynal & Hitchcock, 1947

Published 21 April 1947 @ $3.00

Printed by The Cornwall Press, New York

Jacket design: Robert Hallock

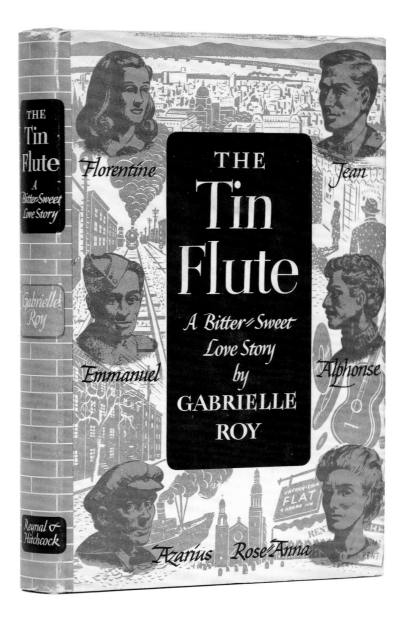

St-Vital, le 25 mai 1947.

Chère madame Guay,

Étant en voyage il me serait difficile de me rendre à votre désir que j'autographie un volume pour vous. Croyez que je le ferais avec plaisir si des nécessités de déplacements ne m'en empêchaient.

Cependant voici une phrase à votre intention que vous pourrez conserver dans votre volume si, toutefois, cela peut vous plaire.

Pour madame J. O. R. Guay
avec mes remerciements pour
sa belle lettre.

Gabrielle Roy.

P.S. Je suis née en effet, rue Deschambault et je dois être de la famille dont vous avez gardé le souvenir.

Mme J. O. R. Guay
31, rue St. Jubinin,
Victoriaville
P.Q.

Holograph letter responding to a request for the author's signature to a copy of The Tin Flute

15

[NOVA SCOTIA]

MacLennan, Hugh

The Precipice

Toronto: William Collins Sons & Company, 1948
Published 17 June 1948 @ $3.00
Printed by The Hunter-Rose Company Limited, Toronto
Signed and inscribed

1948

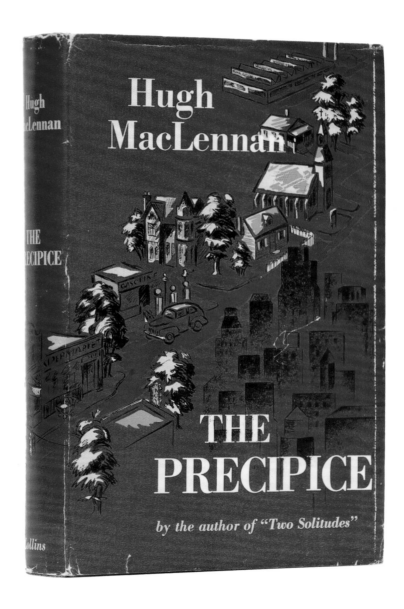

16

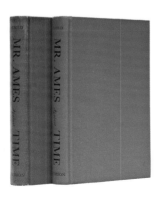

[ONTARIO]

Child, Philip (Albert)

Mr. Ames Against Time

Toronto: The Ryerson Press, 1949
Published September 1949 @ $3.00
Printed by The Ryerson Press, Toronto
Jacket illustration: (signed) Steven

< Binding variants: strong greenish blue and
moderate greenish blue

[QUEBEC]

Guevremont, Germaine

The Outlander

Translated by Eric Sutton

A Whittlesey House Book

New York, London, and Toronto: McGraw-Hill Book
 Company, Inc.

Published 1 February 1950 @ $3.00

Printed by The Vail-Ballou Press, Binghamton, New York

1950

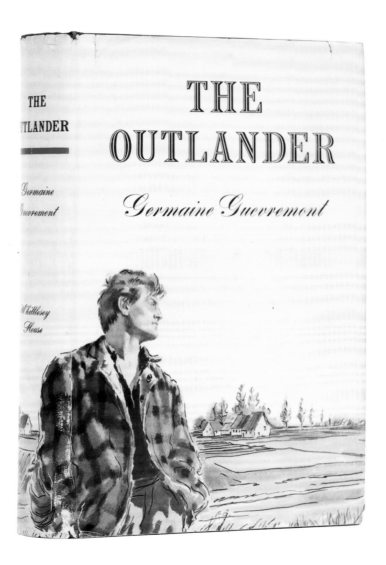

Dear Isaak Hunter,

 To spare your time and your reading,
I have underligned chapter 6 and page 265 .

 For nine years I was Sorel correspondent
for the Gazette . Without any experience I signed a
contract with Mr. MacMahon at eleven o'clock a.m. and
at twelve, the church burned. It was a real "Special to
the Gazette " . Lost and lonesome I learned to love
wild birds . And then in Montreal I wrote this book . *Still* *Le Survenant* .
Although of the quiet type, as birds, it was published
in French first in Montréal, then in Paris^. After in
New-york and in England. As this happened quite a few
years ago, it is less "gênant" to mention it *to you*

 Sincerely

 Germaine Guèvremont

 Germaine Guèvremont
 1010 Sherbrooke St- East .

Typed letter signed, laid into an inscribed copy to a reader
discussing her writing career, the publication history of
The Outlander *and wild birds in the novel*

Callaghan, Morley

The Loved and the Lost

Toronto: The Macmillan Company of Canada Limited, 1951

Published 22 March 1951 @ $3.00

Printed by H. Wolff Book Manufacturing Company Inc.,
 New Jersey

Jacket design: Leo Manso

Signed

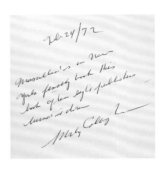

> *"Feb 24/72 | Macmillan's in New | York finally took this | book after eight publishers | turned it down | Morley Callaghan"*

1951

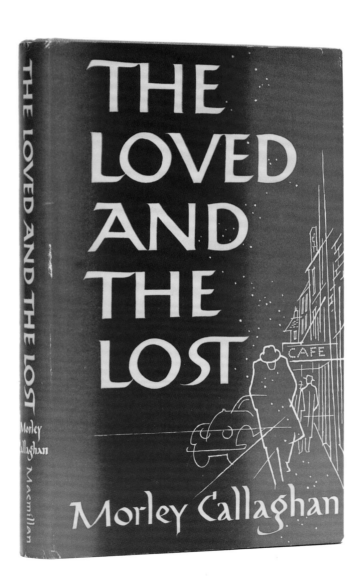

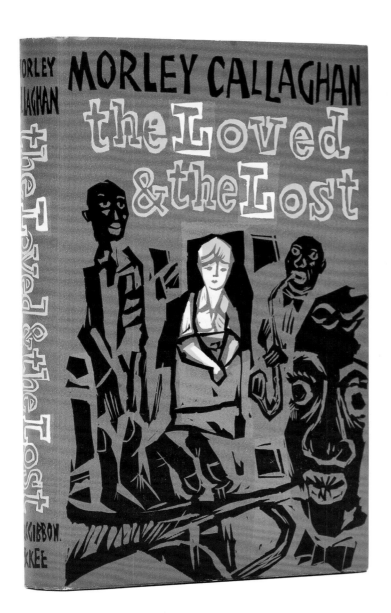

The Loved and the Lost
London: MacGibbon and Kee, 1961
Published 16 October 1961 @ 18/
Printed by Compton Printing Works (London) Ltd.,
 London, Great Britain
Jacket design: Aleksander Werner

[NEW BRUNSWICK]

Walker, David (Harry)

The Pillar

London: Collins, 1952

Published 7 January 1952 @ 12/6 (Britain) $3.00 (Canada)

Printed by Collins Clear-Type Press, London and Glasgow

Jacket design: Sheila Robinson

Signed

1952

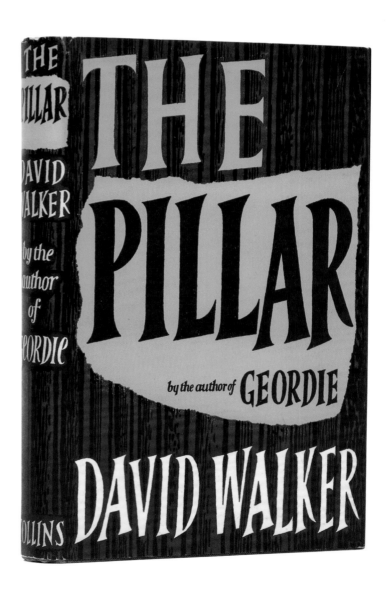

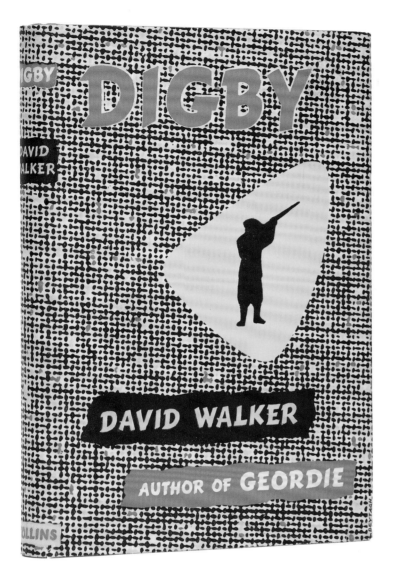

[NEW BRUNSWICK]

Walker, David (Harry)

Digby

London: Collins, 1953
Published 20 August 1953 @ 10/6 (Britain) mid-September
 @ $2.75 (Canada)
Printed by Collins Clear-Type Press, London and Glasgow
Jacket design: (signed) Beytagh
Review copy

[ONTARIO]

Gouzenko, Igor

The Fall of a Titan

London: Cassell & Company Ltd., 1954

Published 24 June 1954 @ 16/ (Britain) 26 June 1954
 @ $3.75 (Canada)

Printed by Hazell Watson and Viney Ltd.,
 Aylesbury and London

Jacket design: Igor Gouzenko

Signed

Endpaper drawings by Gouzenko >

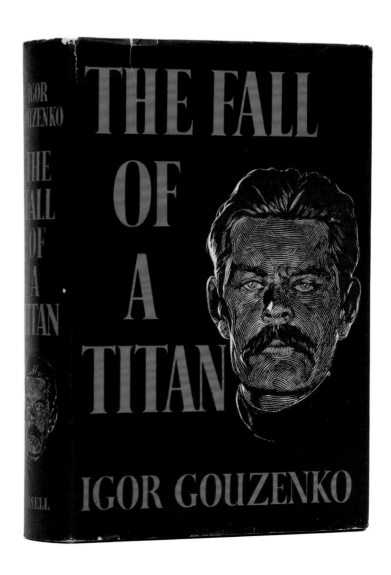

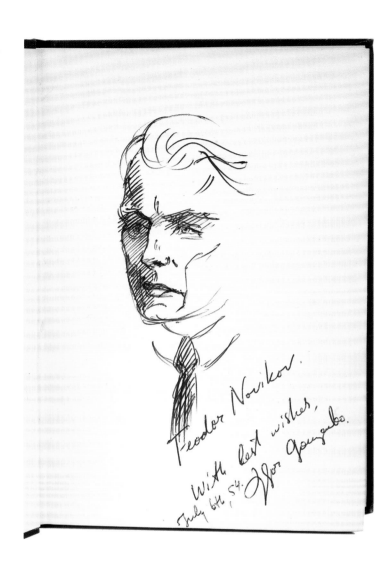

Teodor Novikov.

With best wishes,

July 6th, 54. Igor Gouzenko.

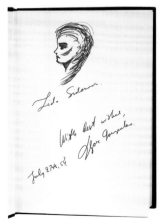

Lida Sidorow.

With best wishes,

Igor Gouzenko.

July 27th, 54.

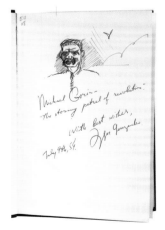

Michael Gorin —
"The stormy petrel of revolution."

With best wishes,

July 9th, 54. Igor Gouzenko.

[QUEBEC]

Shapiro, Lionel (Sebastian Berk)

The Sixth of June

New York: Doubleday & Company, 1955
Published 4 August 1955 @ $3.95 (USA) $4.75 (Canada)
Printed by Doubleday & Company, Inc., Hanover,
 Pennsylvania
Jacket design: Len Oehmen
Review copy, signed

1955

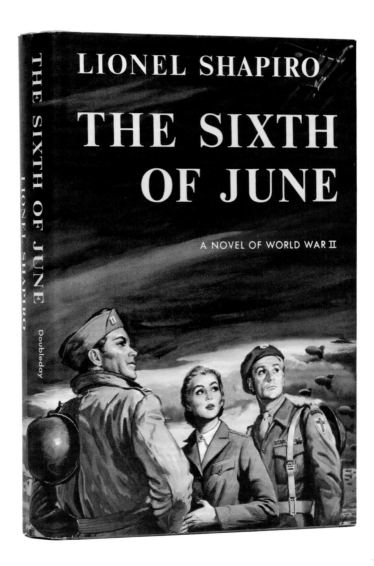

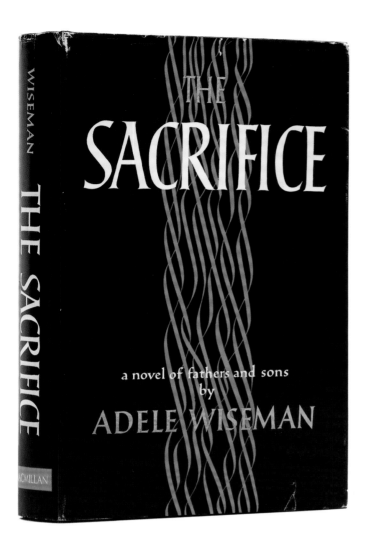

[MANITOBA]

Wiseman, Adele

The Sacrifice

Toronto: The Macmillan Company of Canada Limited, 1956
Published 13 September 1956 @ $3.95
Printed by The Colonial Press Inc., Clinton, Massachusetts
Jacket design: Ismar David

The Sacrifice

London: Victor Gollancz Ltd., 1956

Published 22 October 1956 @ 16/

Printed by Richard Clay and Company Ltd., Bungay, Suffolk, Great Britain

> Presentation copy, inscribed on day of publication, with author's self caricature "With much love | to my Aimaleh. | October 22, 1956 | Adele | Wiseman"

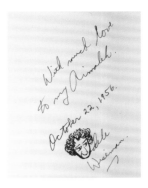

THE
SACRIFICE
BY
ADELE
WISEMAN

THE
SACRIFICE

a novel by

ADELE WISEMAN

Sarah Gertrude Millin writes:

"One can hardly imagine that the author of this unique book about this unique people is a girl of twenty-six."

David Daiches writes:

"The total achievement is of a very high order and reveals a novelist of exciting promise. It is a most impressive work, and a remarkable achievement for a girl in her mid-twenties. Miss Wiseman is to be congratulated on an unusually fine first novel."

Saul Bellow writes:

"There is something very new and unusual about it ... What impresses me most about

GOLLANCZ

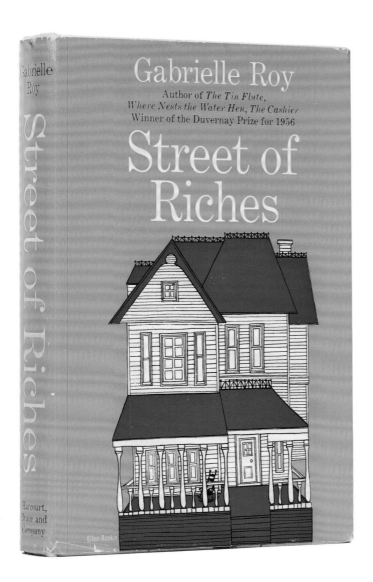

[MANITOBA]

Roy, Gabrielle

Street of Riches

Translated by Harry Binsse
Toronto: McClelland and Stewart, 1957
Published 11 October 1957
Printed by Quinn and Boden Company, Rahway, New York
Jacket design: Ellen Raskin

[QUEBEC]

McDougall, Colin (Malcom)

Execution

Toronto: The Macmillan Company of Canada Limited, 1958
Published 26 September 1958 @ $3.50
Printed by Hazell Watson and Viney Ltd., Aylesbury and
 Slough, England
Jacket design: Ken Dallison
Signed

> Binding without dust jacket

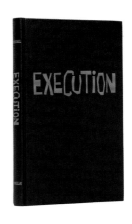

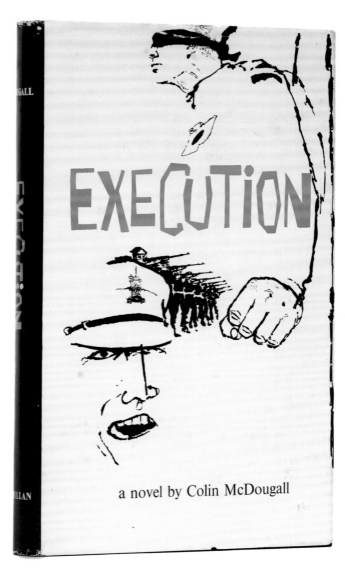

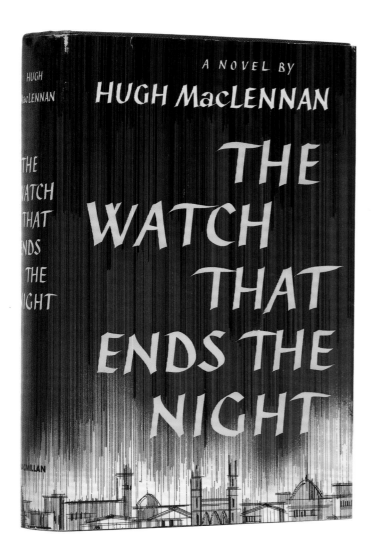

[NOVA SCOTIA]

MacLennan, Hugh
The Watch That Ends the Night

Toronto: Macmillan, 1959
Published 13 February 1959 @ $3.95
Printed by The Hadden Craftsmen, Scranton, Pennsylvania
Jacket design: Philip Grushkin
Association copy, signed

[QUEBEC]

Moore, Brian

The Luck of Ginger Coffey

Boston and Toronto: Little, Brown and Company, 1960
Published 4 August 1960 @ $4.00
Printed by The Riverside Press, Cambridge, Massachusetts
Jacket design: Emil Antonucci
Review copy

> *The Luck of Ginger Coffey*
London: Andre Deutsch Limited, 1960
Published 26 August 1960 @ 15/
Printed by Ebenezer Baylis and Son Ltd., Worcester and London

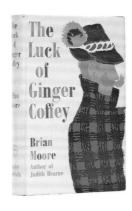

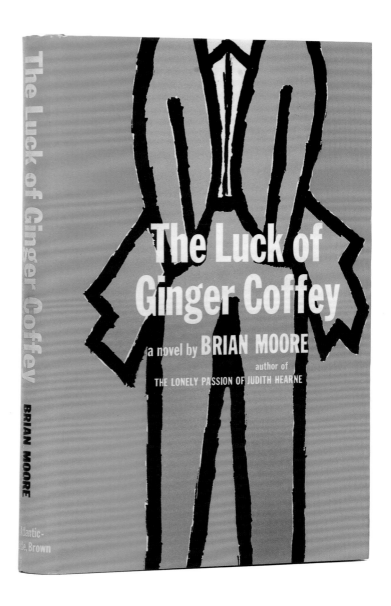

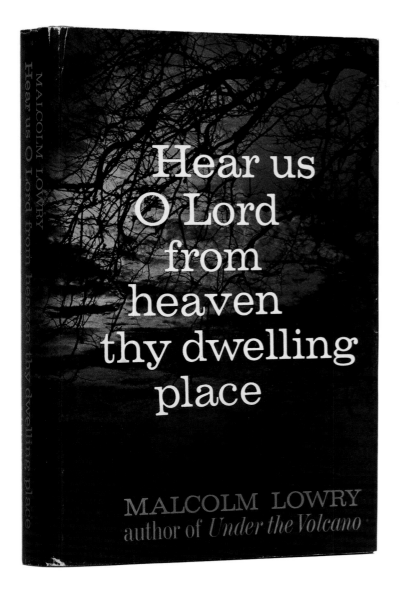

[BRITISH COLUMBIA]

Lowry, Malcolm

Hear Us O Lord from Heaven thy Dwelling Place

Philadelphia and New York: J.B. Lippincott Company, 1961
Published 17 April 1961 @ $4.95
Printed by The Colonial Press Inc., Clinton, Massachusetts
Jacket design: Bill English
Review copy

[ONTARIO]

Dobbs, Kildare

Running to Paradise

Toronto: Oxford University Press, 1962
Published 8 November 1962 @ $3.50
Printed by Hazell, Watson and Viney Ltd.,
 Aylesbury and Slough, England
Jacket art: Leo Rampen
Signed

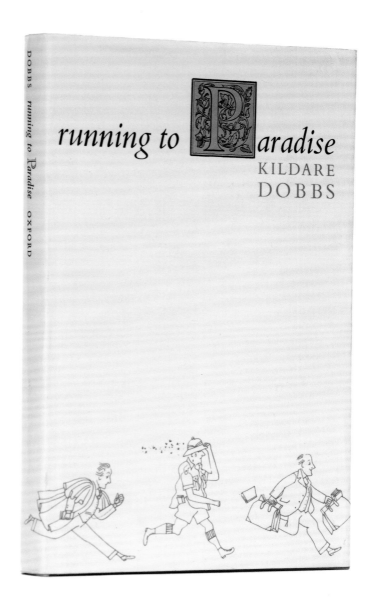

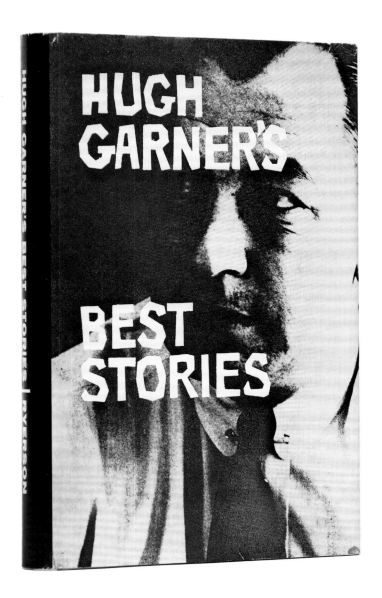

[ONTARIO]

Garner, Hugh

Hugh Garner's Best Stories

Toronto: The Ryerson Press, 1963
Published 24 September 1963 @ $4.95
Printed by The Ryerson Press, Toronto
Signed

[ONTARIO]

LePan, Douglas

The Deserter

Toronto and Montreal: McClelland and Stewart, 1964

Published 7 November 1964 @ $5.95

Printed by Harpell's Press Co-Operative, Gardenvale, Quebec

Jacket design: Frank Newfeld

Jacket art: John Zehethofer

Signed

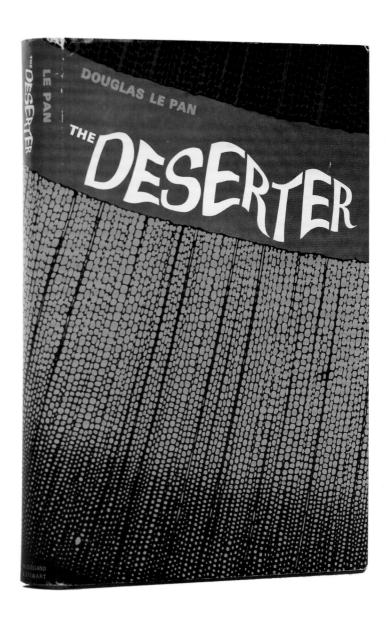

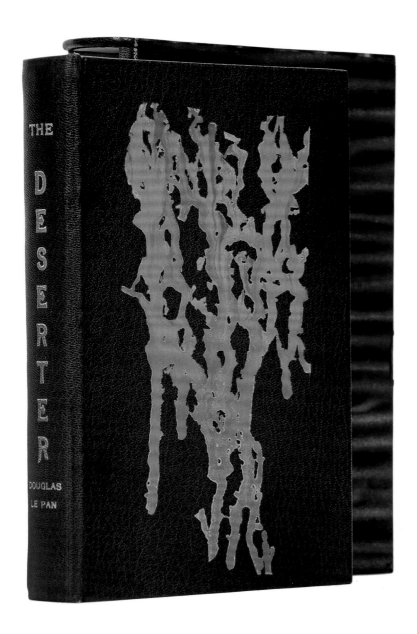

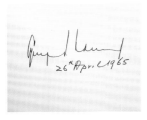

Governor General of Canada presentation copy
Signed and dated 26 April 1965 by Georges Vanier
Copy rebound in full leather with a red and gilt design on
 the front and rear covers by Louis Forest, Relieur d'art

No fiction award was given in 1965

[MANITOBA]

Laurence, Margaret

A Jest of God

Toronto and Montreal: McClelland and Stewart, 1966
Published 10 September 1966 @ $5.00 (cloth) $2.50 (paper)
Printed by Universal Printers, Winnipeg
Jacket design: Warren Chappell

No fiction award was given in 1967

1966

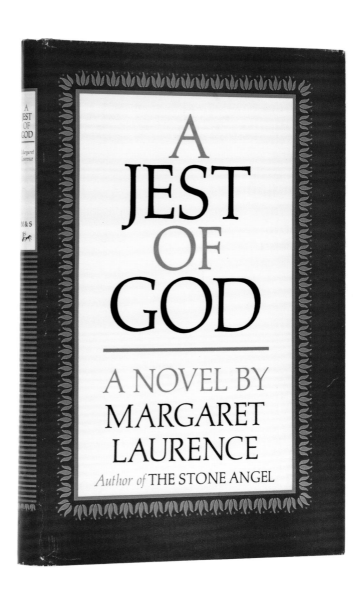

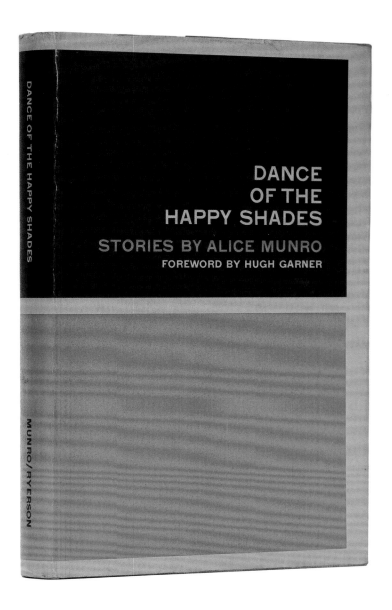

DANCE
OF THE
HAPPY SHADES

STORIES BY ALICE MUNRO

FOREWORD BY HUGH GARNER

THE RYERSON PRESS

For Al Purdy
good wishes
Alice Munro

[ONTARIO]

Munro, Alice

Dance of the Happy Shades

Foreword by Hugh Garner

Toronto: The Ryerson Press, 1968

Published September 1968 @ $6.95

Printed by The Ryerson Press, Toronto

< *Association copy inscribed to Al Purdy*

[ALBERTA]

Kroetsch, Robert

The Studhorse Man

Toronto: Macmillan of Canada, 1969

Published 3 November 1969 @ $4.50

Printed by Unwin Brothers Limited, Woking and London,
 Great Britain

Jacket design: Kenneth Carroll

Signed

1969

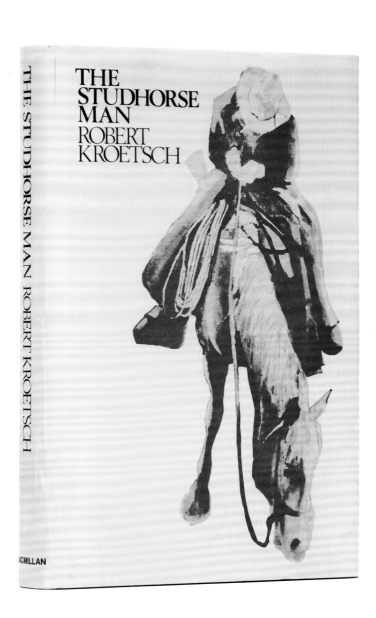

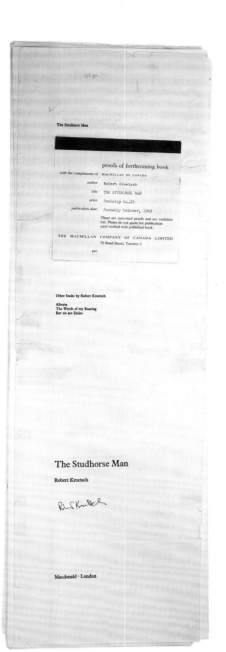

proofs of forthcoming book

with the compliments of MACMILLAN OF CANADA

author Robert Kroetsch

title THE STUDHORSE MAN

price Probably $4.95

publication date Probably October, 1969

These are unrevised proofs and are confidential. Please do not quote for publication until revised with published book.

THE MACMILLAN COMPANY OF CANADA LIMITED
70 Bond Street, Toronto 2

per

Other books by Robert Kroetsch

Alberta
The Words of my Roaring
But we are Exiles

The Studhorse Man

Robert Kroetsch

Macdonald · London

I

Strangely enough, I am never more sane than when confined by the authorities to this droll institution. The manured fields, the manicured gardens, the peace and quiet of locked doors, the reassuring presence of uniformed nurses and muscular attendants, the quaintly distressed inmates—all conspire to flood my quaint middle-aged body to bursting with love for my poor dear fellow men.

Why then I should want to tell so violent a story, I hardly know: but as a young man I proposed to write a novel. For many years I gathered information on a peculiar figure who influenced greatly my youth, only to discover when finally I commenced to write that a simple biography would be more appropriate: scholars in the future will want every wisp of detail concerning the man who reared that famous foundation sire, the Lepage stallion.

The mere truth will suffice, I discovered, and discovering this, I, ever so humbly, elected to become his Plutarch and his Boswell. Granted, I spent hardly two dozen afternoons with Hazard Lepage: but I got the story from others as well. I was curious; I went out of my way to hear of incidents, to examine evidence and motives. Martha, after all, is my cousin; and she and Hazard were engaged for thirteen years. I sat in country beer parlours listening to the chitchat and gossip of idle men. I walked, when first to do so, the routes that were Hazard's routes. I plundered various newspaper files. Understand then, I entreat you, that this is not my story.

Hazard had to get hold of a mare. He was desperate. In an area centred on a string of seven towns he was the only remaining studhorse man, yet in the previous season he had travelled the

7

hundreds of miles of dirt roads in a two-wheeled cart, pulled by his old gelding, leading his beautiful blue beast of a virgin stallion —and he had found not one farmer with a mare that wanted covering.

He was a truly desperate man. Extinction or survival was quite simply to be the fate of the breed of horse he alone had preserved through six generations; thus, penniless as he was, and he had been reduced to living on porridge for nearly a month, he hit on the scheme of somehow buying a mare. With commendable determination he found a neighbour who would sell his single remaining horse for $20.00—upon closing his fist on spot cash. 'No money, no mare,' the unkind neighbour commented to clinch the deal, as if Hazard might not be financially reliable.

Fortunately, the war was in progress, the government was scouring Alberta for bones. BONES FOR WAR, the ads and posters read:

BRING IN YOUR BONES
WE PAY CASH

In the same newspaper that carried this federal proclamation in a notice from an uncle of mine saying he planned to be in the town of Burkhardt from Thursday, 8 March, to Saturday, 10 March, with the patriotic intent of purchasing all available loads of scrap iron, rags, bones, and miscellaneous. Hazard, travelling the countryside as was his wont, knew where to find every skeleton of a cow, every buffalo skull, even, it must be added, every carcass of a horse. He read my uncle's notice and in twenty-five days gathered together a pile of bones that he guessed to be worth at least as many dollars.

Thus it was that on Thursday, 8 March, Hazard Lepage got out of bed three hours earlier than usual—he was sleeping in his fifth bed, the significance of which I shall explore later—he made his porridge and tea, combed his hair and beard, put on his overshoes and mackinaw and fur cap, and precisely at 8.15 he went outside to dig a hole in the snowbank covering his recently accumulated pile of bones.

8

By 10.10 he was kicking around in the powdered snow, hitting almost nothing. He found a horse's skull, knocked it clean on the sleigh's bolster, tossed it on to the pile that now humped out of the sleigh's weathered green box. He gave one last kick, found a jawbone, and then, knocking the snow off his wet leather mitts, out of his beard, he crawled up from the hole he had by this time dug to a depth of nearly six feet. He cursed rather freely the pain in his back.

Shading his eyes against the really blinding glare (they were brown eyes, dark, large; eyes that compelled women to speak, as would appear), he looked out across the Cree River valley and Wildfire Lake towards the horizon. An arch of pale blue sky held off the white fur of cloud from the tree-scratched white of the low hills. Obviously, the chinook was not to blow for hours.

Hazard recognized that the snow cover must quickly vanish from the roads. He hurried to his giant, square foot of a house: a mansion-like affair, it was surrounded on three sides by verandas, one above the other, giving the effect of the house deck of a sternwheeler. He limped up the gangplank he now used in place of the veranda steps; he waited when his wet palm stuck to the huge iron knocker; then he was inside and warm in the cold hallway.

The thought of departing was somehow and suddenly unbearable. Perhaps he remembered the days when he could take his leave relaxed in the knowledge that in one week a dozen mares might be united to his horse. God knows, we have all confronted failure. But Hazard, instead of hurrying to harness his team, took off his mackinaw; he went into the dining room and opened the bay window—and quietly, without haste, he cleaned the pile of steaming turds from behind the gelding, pitched them out of the window, put down fresh straw. Then he went into the parlour; at his leisure he built behind Poseidon a pyramid of turds on a pad of straw, and lifting his creation on a four-tined fork—I have used the fork myself, its handle worn bright and smooth by love—he returned fastidiously to the adjacent room and the open window.

The town of Burkhardt, directly north from the mansion, is

9

The Studhorse Man
Long uncorrected galleys
Signed

[ONTARIO]

Godfrey, Dave

The New Ancestors

Toronto and Chicago: New Press, 1970
Published 23 October 1970 @ $10.00
Printed by The Hunter-Rose Company, Canada
Jacket design: Peter Maher | Photograph: Brian Pickell
Association copy inscribed to librarian

*"For Mrs. Jean Headon | Who made the library | which made
me a writer. | Dave Godfrey | December, 1970"*

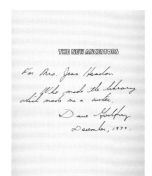

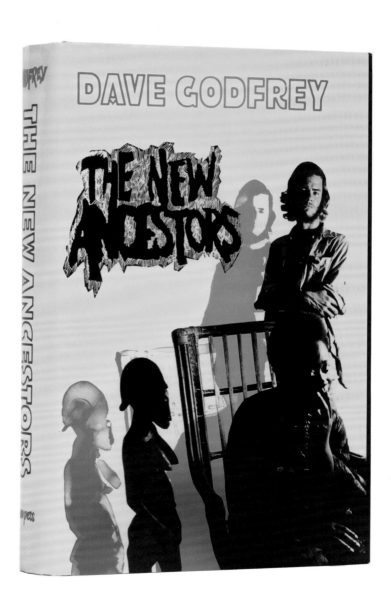

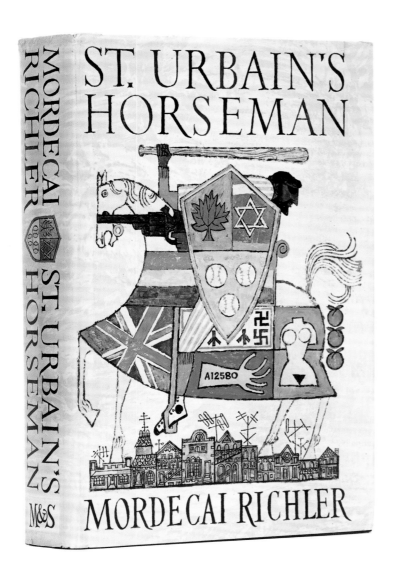

[QUEBEC]

Richler, Mordecai

St. Urbain's Horseman

Toronto: McClelland and Stewart Limited, 1971

Published 22 May 1971 @ $7.95

Printed by T.H. Best Printing Company Limited,
 Don Mills, Ontario

Jacket design: Alice and Martin Provensen

[ONTARIO]

Davies, Robertson

The Manticore

Toronto: Macmillan of Canada, 1972
Published 20 October 1972 @ $7.95
Printed in Canada
Jacket design: Hal Siegel
Signed

1972

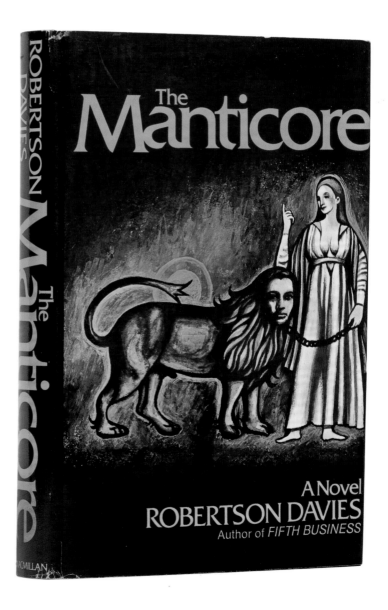

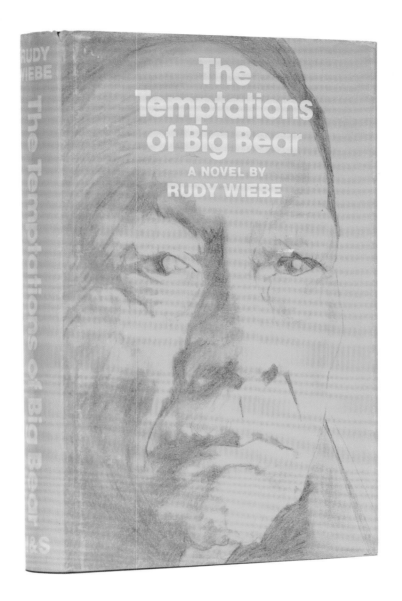

[ALBERTA]

Wiebe, Rudy

The Temptations of Big Bear

Toronto: McClelland and Stewart, 1973

Published 15 September 1973 @ $8.95

Printed by John Deyell Limited, Willowdale, Ontario

Jacket illustration: Hilary Hallpike

Signed

[MANITOBA]

Laurence, Margaret

The Diviners

Toronto: McClelland and Stewart Limited, 1974
Published 18 May 1974 @ $8.95
Printed by T.H. Best Printing Company Limited,
 Don Mills, Ontario
Jacket design: Muriel Nasser

> Association copy inscribed to musician at author's
Lakefield, Ontario, church
*"Geoffrey— | with all best | wishes— | Margaret Laurence |
Lakefield 1980"*

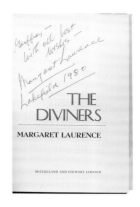

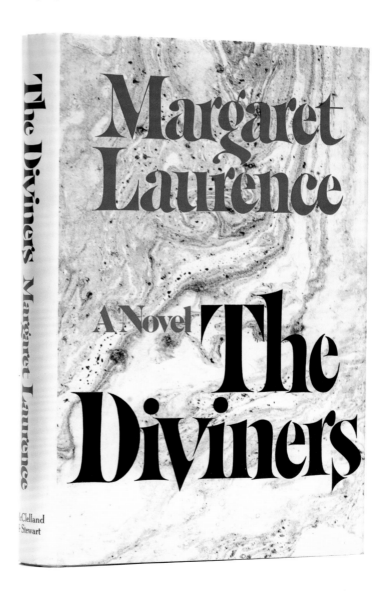

8 Regent Street,
Lakefield, Ontario.

16 Dec 80

Dear Geoffrey:

I may not be able to be at the final service in the church,
before you leave, because I will be in T.O. for Christmas, at my
daughter's place, but also may have to stay on because my best friend
has had a very serious operation and she will likely be home about that
time, and I want to be there for a couple of weeks, just to do some
practical things such as looking after her and making meals for her
child and her husband. First things first. But I do want you to know
that it has been a great pleasure to know you, and to experience your
music in our church -- we've been so lucky , Geoffrey, to have your
talents there. I guess we have also been much honoured to have someone
of your ability and stature, in the world of music, here with us. I
just want to tell you that I have been glad to know you as a friend,
and privileged to share your music in a village church, our village and
home. I do wish you every good wish in your new appointment. You
will, of course, always go on and share your love of music with whoever
you happen to be living amongst. I think that is, in some way, a gift
of grace.

With very best wishes,

Margaret Laurence

Margaret Laurence

Typed letter, signed, 16 December 1980 addressed to
musician at her Lakefield, Ontario, church discussing
Christmas, visiting her daughter and best friend (Adele
Wiseman) during the holidays

Songs from *The Diviners* phonograph record 33.3 rpm

McClelland and Stewart Limited in association with
 Heorte Music, 1973

Lyrics by Margaret Laurence / Music by Ian Cameron /
 Heorte Music C.A.P.A.C.

Recording remastered and produced by Quality Records

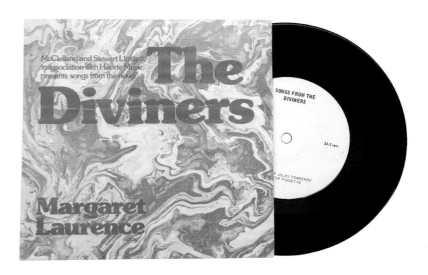

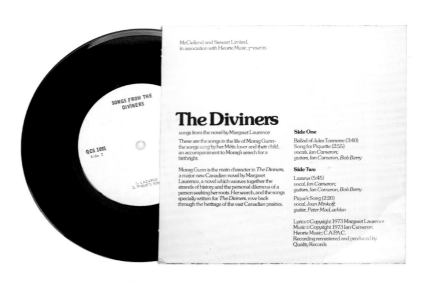

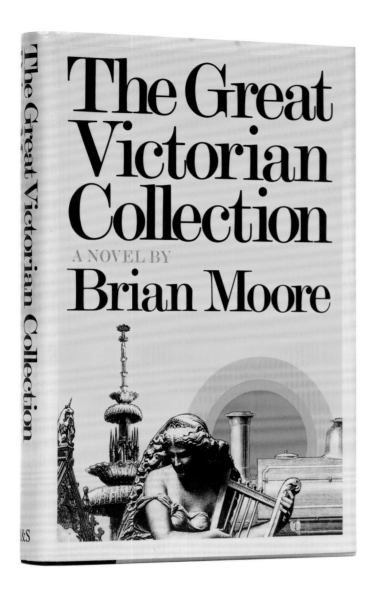

[QUEBEC]

Moore, Brian

The Great Victorian Collection

Toronto: McClelland and Stewart Limited, 1975

Published 7 June 1975 @ $7.95

Printed by The American Book-Stratford Press, Inc., New
 York, and The Vail-Ballou Press, Inc., Binghamton, NY

Jacket design: Janet Halverson

[ONTARIO]

Engel, Marian

Bear

Toronto: McClelland and Stewart, 1976
Published 10 April 1976 @ $7.95
Printed in Canada
Signed

> Binding variants: medium bluish green and greyish blue

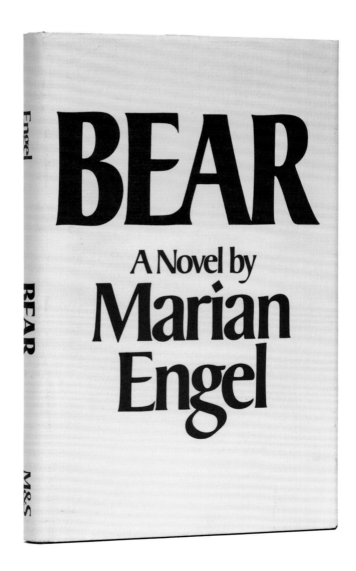

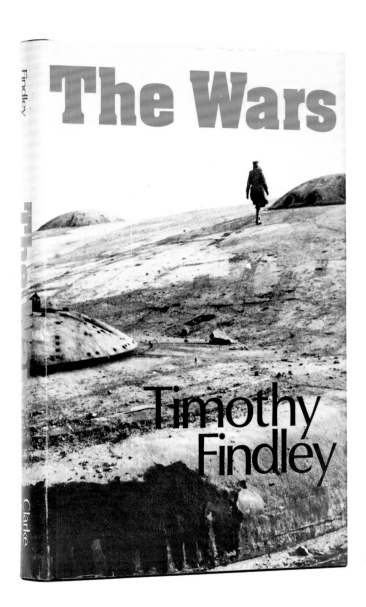

[ONTARIO]

Findley, Timothy

The Wars

Toronto and Vancouver: Clarke, Irwin & Company, 1977
Published 8 October 1977 @ $9.95
Printed by John Deyell Limited
Jacket photo: The Public Archives of Canada and
 Historical Services
Review copy, signed

[ONTARIO]

Munro, Alice

Who Do You Think You Are?

Toronto: Macmillan of Canada, 1978
Published 11 November 1978 @ $10.95
Printed in Canada
Jacket design: Catherine P. Wilson
Illustration: Ken Danby
Signed

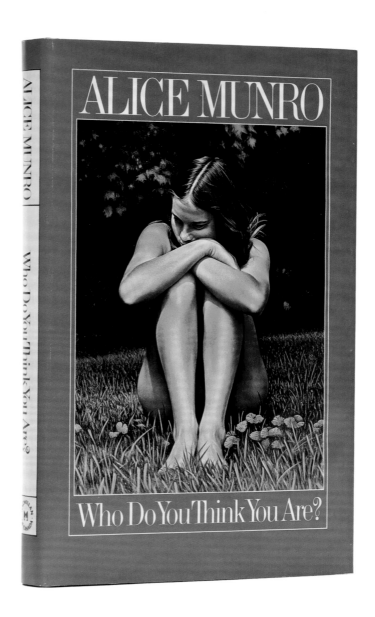

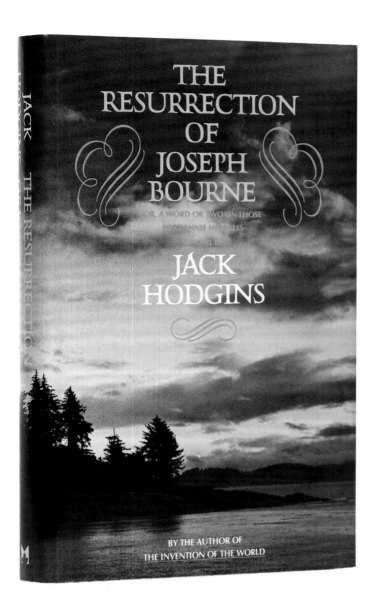

[BRITISH COLUMBIA]

Hodgins, Jack

The Resurrection of Joseph Bourne

Toronto: Macmillan of Canada, 1979
Published 15 September 1979 @ $12.95
Printed in Canada
Jacket design: A Peppermint Design
Photograph: *Beautiful British Columbia* magazine
Signed

[BRITISH COLUMBIA]

Bowering, George

Burning Water

Don Mills: Musson Book Company, 1980
Published 1 September 1980 @ $14.95
Printed in Canada
Jacket design: Maureen Heel-Henderson
Signed

1980

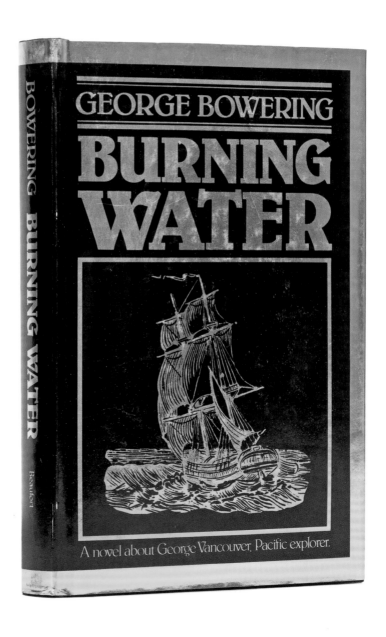

54

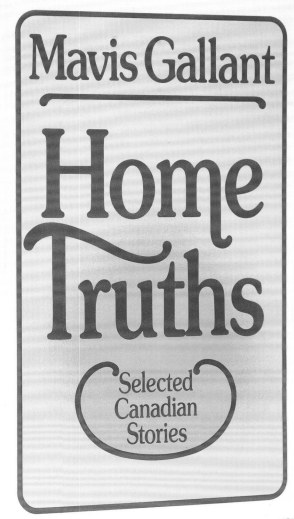

[QUEBEC]
Gallant, Mavis
Home Truths: Selected Canadian Stories

Toronto: Macmillan of Canada, 1981
Published 24 October 1981 @ $15.95
Printed by The Hunter-Rose Company, Toronto
Jacket design: Helen Mah / The Dragon's Eye Press
Review copy, signed

[SASKATCHEWAN]

Vanderhaeghe, Guy

Man Descending

Toronto: Macmillan of Canada, 1982
Published 30 April 1982 @ $16.95
Printed by The Hunter-Rose Company, Toronto
Jacket design: Richard Miller / A Peppermint Design
Illustration: Graham Coughtry
Signed

1982

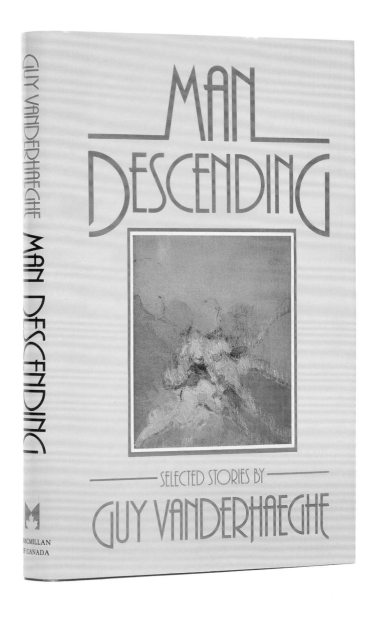

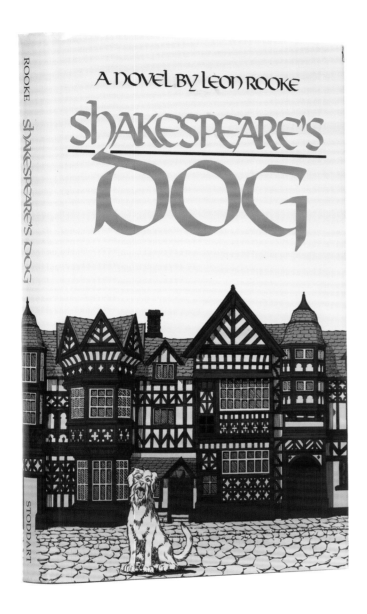

[ONTARIO]

Rooke, Leon

Shakespeare's Dog

Toronto: Stoddart, 1983
Published 4 May 1983 @ $14.95
Printed by The Haddon Craftsmen, Inc., Scranton,
 Pennsylvania
Jacket design: Brant Cowie / Artplus Ltd.
Review copy, signed

Shakespeare's Dog
New York: Alfred A. Knopf, 1983
Published 3 May 1983 @ $10.95
Printed by The Haddon Craftsmen, Inc., Scranton,
 Pennsylvania
Jacket design: James Laughlin
Illustration: Gary Reed Price/ JāeL Graphics
Review copy, signed

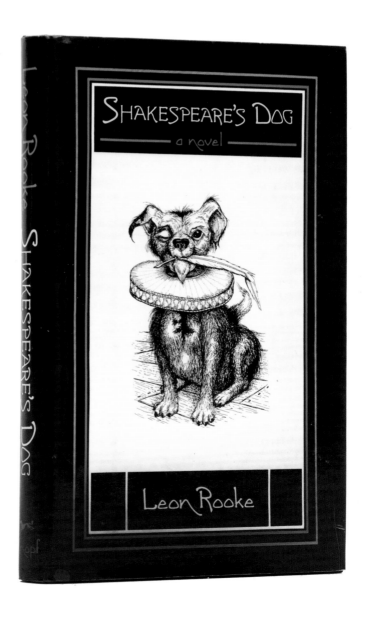

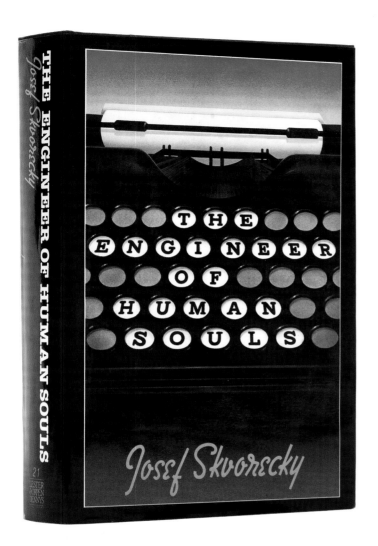

[ONTARIO]

Škvorecký, Josef

The Engineer of Human Souls

Translated by Paul Wilson

Toronto: Lester & Orpen Dennys Publishers, 1984

Published 30 June 1984 @ $19.95

Printed by The Haddon Craftsmen, Scranton, Pennsylvania

Jacket design: Fred Marcellino

Signed by author and translator

[ONTARIO]

Atwood, Margaret

The Handmaid's Tale

Toronto: McClelland and Stewart, 1985
Published 5 October 1985 @ $22.95
Printed by T.H. Best Printing Company Limited,
 Don Mills, Ontario
Jacket design: Tad Aronowicz | Illustration: Gail Geltner

> Presentation copy inscribed to Gwendolyn MacEwen,
winner of two Governor General's Awards for poetry
"For Gwen | with all best wishes— | Peggy A."

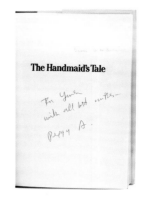

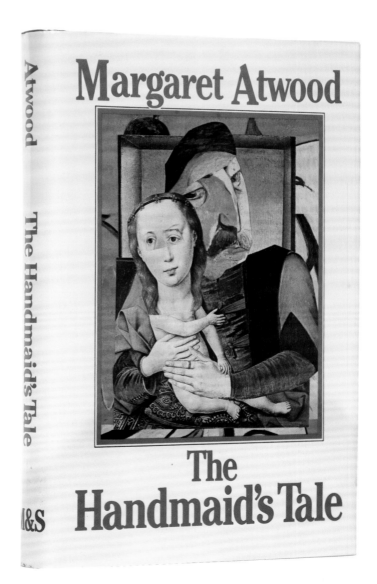

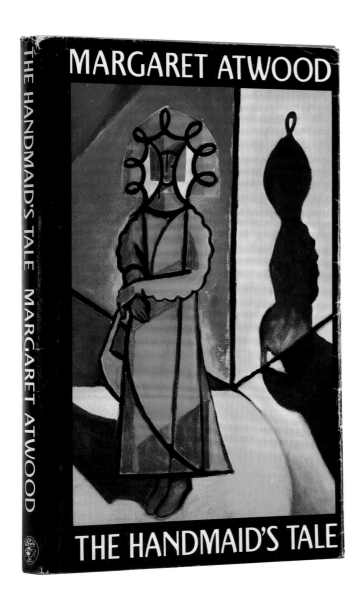

Trial dust jacket for Jonathan Cape edition by Ian Hands

[ONTARIO]

Munro, Alice

The Progress of Love

A Douglas Gibson Book

Toronto: McClelland and Stewart, 1986

Published 20 September 1986 @ $22.95

Printed by Gagné Ltée, Canada

Jacket illustration: Alex Colville

Douglas LePan's copy, signed

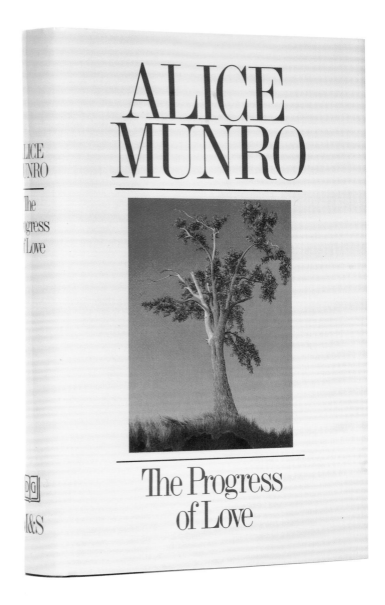

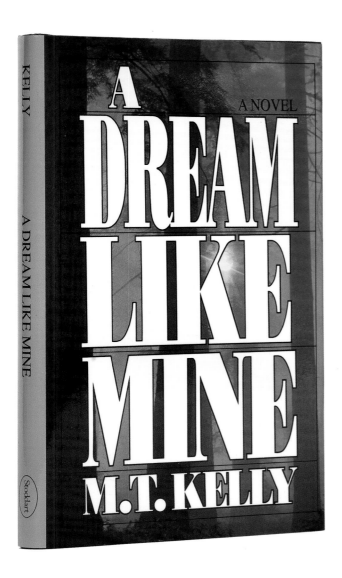

[ONTARIO]

Kelly, M.T. (Milton Terrence)

A Dream Like Mine

Toronto: Stoddart Publishing Company Limited, 1987
Published 24 October 1987 @ $19.95
Printed in Canada
Jacket design: Brant Cowie / Artplus Limited
Photograph: Four by Five
Review copy, signed

[NEW BRUNSWICK]
Richards, David Adams
Nights Below Station Street

Toronto: McClelland and Stewart, 1988
Published 21 May 1988 @ $22.95
Printed in Canada
Jacket design: Richard Miller | Illustration: Joe Fleming
Review copy, signed

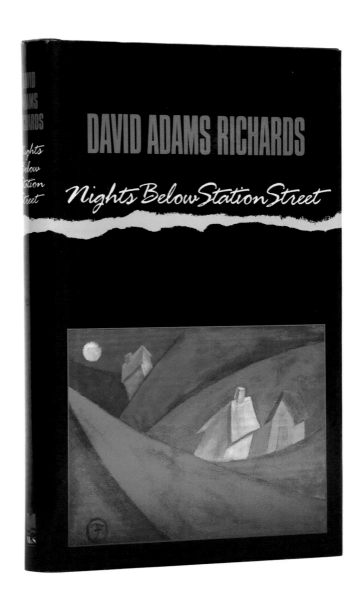

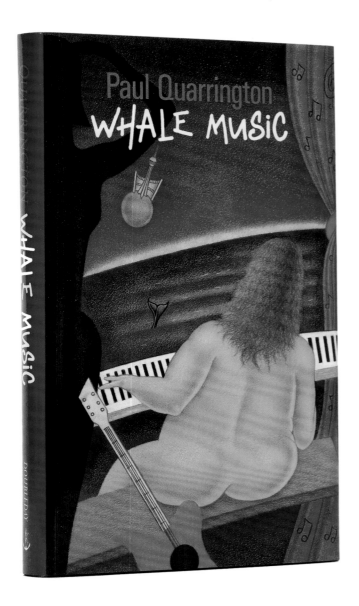

[ONTARIO]

Quarrington, Paul

Whale Music

Toronto: Doubleday Canada Limited, 1989
Published 13 May 1989 @ $22.95
Printed in Canada
Jacket design: The Dragon's Eye Press
Illustration: Jeffrey Harrison
Review copy, signed

[ONTARIO]

Ricci, Nino

Lives of the Saints

Dunvegan, Ontario: Cormorant Books, 1990
Published 14 March 1990 @ $22.95 (cloth) $12.95 (paper)
Printed by Hignell Printing Limited, Winnipeg
Jacket cover art: Maxwell Bates /
 The Canada Council Art Bank
Signed

Published simultaneously in cloth and paper
Published in the United States in 1991 under the revised title
The Book of Saints *by Alfred A. Knopf*

1990

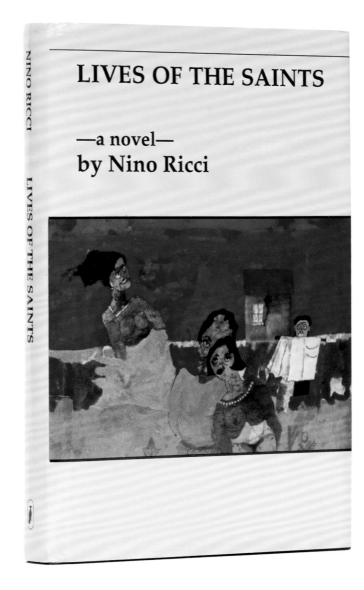

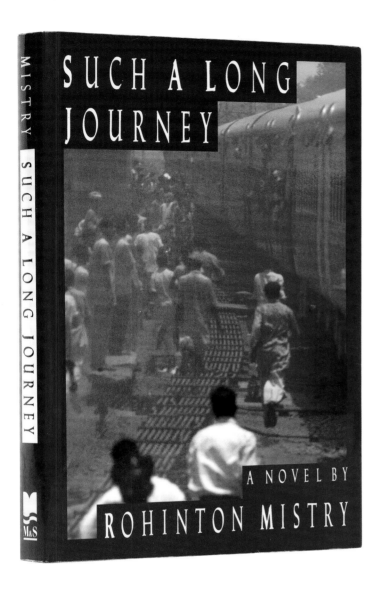

[ONTARIO]

Mistry, Rohinton

Such a Long Journey

Toronto: McClelland and Stewart, 1991
Published 11 May 1991 @ $16.95
Printed in Canada
Front cover design: Chip Kidd
Cover photograph: Marilyn Silverstone / Magnum Photo
Review copy, signed

[ONTARIO]

Ondaatje, Michael

The English Patient

Toronto: McClelland and Stewart, 1992
Published 19 September 1992 @ $26.99
Printed in the United States
Jacket design: AB3 Design
Photograph: Royal Geographical Society
Signed

1992

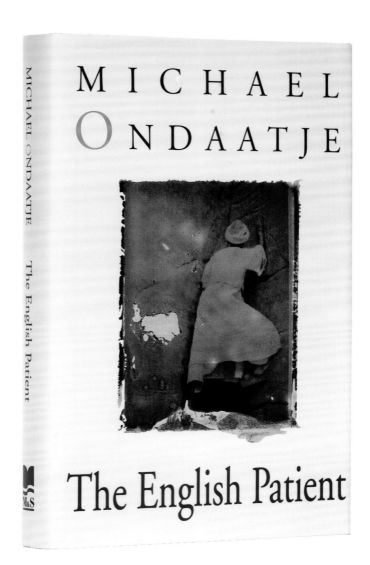

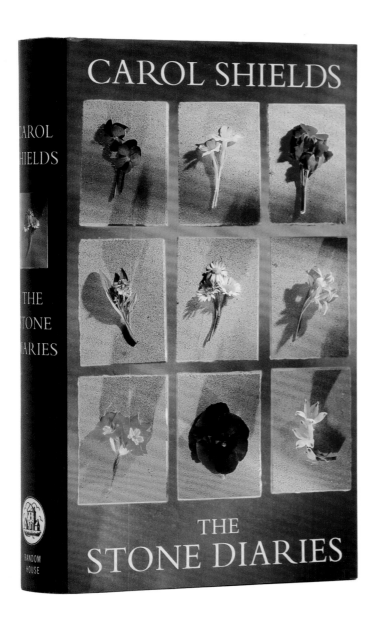

[MANITOBA]

Shields, Carol

The Stone Diaries

Toronto: Random House of Canada, 1993
Published 27 September 1993 @ $26.50
Printed by Clays Ltd., St. Ives plc, Great Britain
Jacket design: Andrea Pinnington
Photography: David Purdie
Signed

[ALBERTA]

Wiebe, Rudy

A Discovery of Strangers

Toronto: Alfred A. Knopf Canada, 1994
Published 27 May 1994 @ $27.00
Printed by R.R. Donnelley, Harrisonburg, Virginia
Jacket design: Sharon Foster Design
Illustration: Toni Onley
Signed

1994

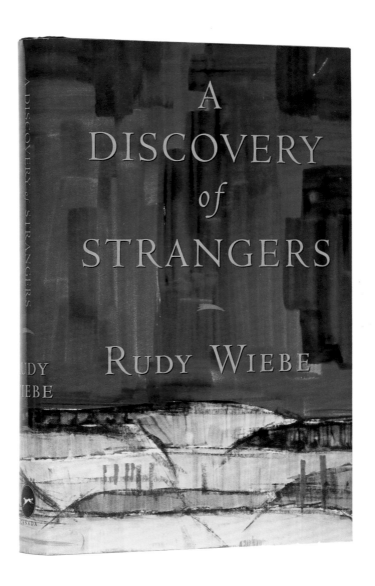

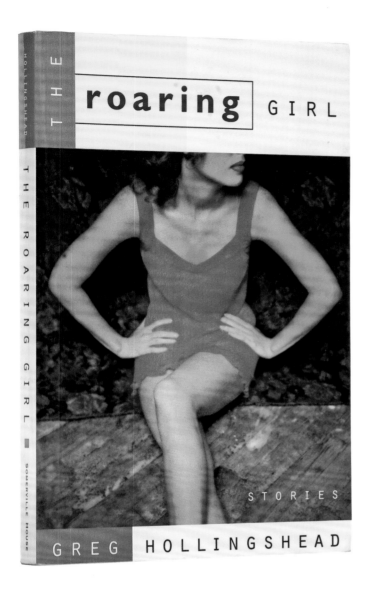

[ALBERTA]

Hollingshead, Greg

The Roaring Girl

A Patrick Crean Book
Toronto: Somerville House Publishing, 1995
Published 16 September 1995 @ $22.95
Printed in Canada
Cover design: Gordon Robertson
Photograph: Barbara Cole
Signed

[SASKATCHEWAN]

Vanderhaeghe, Guy

The Englishman's Boy

Toronto: McClelland and Stewart, 1996
Published 14 September 1996 @ $27.50
Printed in Canada
Jacket design: Brian Bean
Photograph: UPI / Corbis Bettmann
Signed

1996

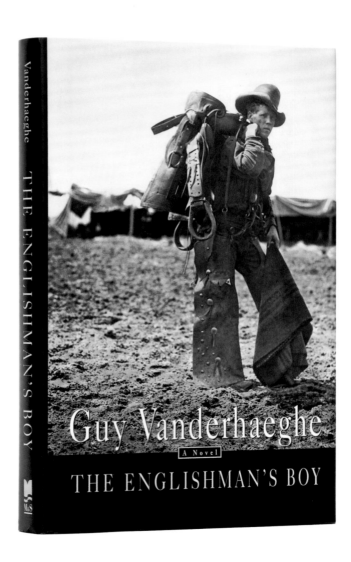

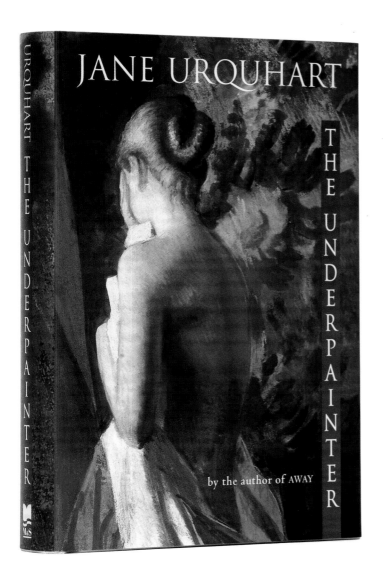

[ONTARIO]

Urquhart, Jane

The Underpainter

Toronto: McClelland and Stewart, 1997
Published 6 September 1997 @ $29.99
Printed in Canada
Jacket design: Kong Njo | Illustration: John Collier
Signed

[ONTARIO]

Schoemperlen, Diane

Forms of Devotion

A Phyllis Bruce Book

Toronto: Harper Collins Publishers, 1998

Published 2 April 1998 @ $25.00

Printed by Quebecor, Fairfield, Pennsylvania

Jacket design: Scott A. Christie of Pylon Design Associates

Signed

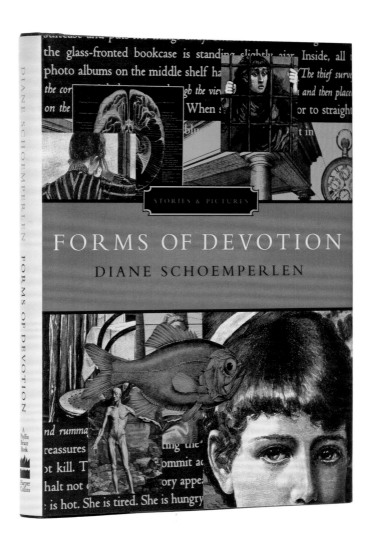

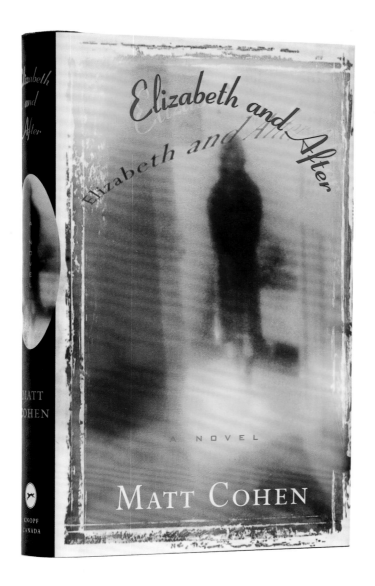

[ONTARIO]

Cohen, Matt

Elizabeth and After

Toronto: Alfred A. Knopf Canada, 1999
Published 2 February 1999 @ $32.95
Printed by Quebecor, Martinsburg, Virginia
Jacket design: Sharon Foster Design
Photograph: Gary Isaacs / Photonica
Signed

[ONTARIO]

Ondaatje, Michael
Anil's Ghost

Toronto: McClelland and Stewart, 2000
Published 22 April 2000 @ $34.99
Printed by Friesens, Altona, Manitoba
Jacket design: Carol Devine Carson and K.T. Njo
Photograph: Jana Leōn
Signed

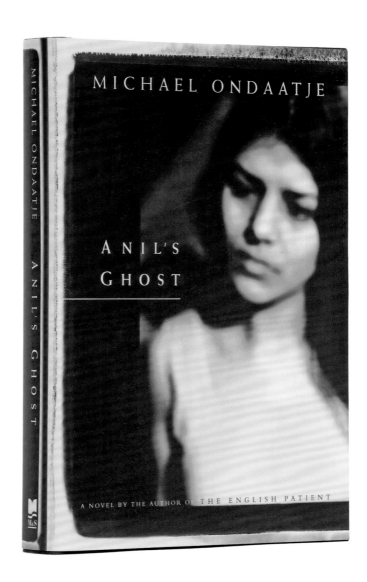

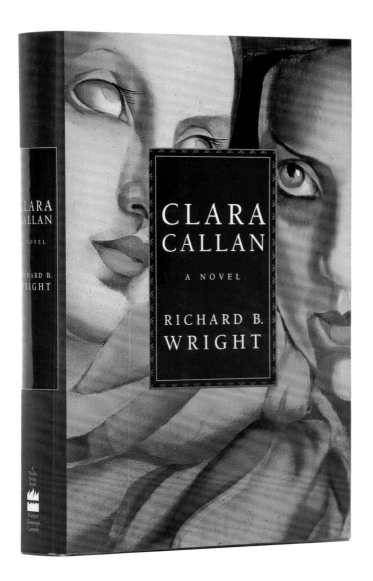

[ONTARIO]

Wright, Richard B.

Clara Callan

A Phyllis Bruce Book
Toronto: Harper Flamingo Canada, 2001
Published August 2001 @ $32.00
Printed in the United States
Jacket design: Pylon
Illustration: Tamara de Lempicka
Signed

[ALBERTA]

Sawai, Gloria

A Song for Nettie Johnson

Regina: Coteau Books, 2001
Published 1 October 2001 @ $18.95
Printed by Houghton Boston, Saskatoon
Cover design: Kate Kokotailo
Illustration: Karl Skaret
Signed

2002

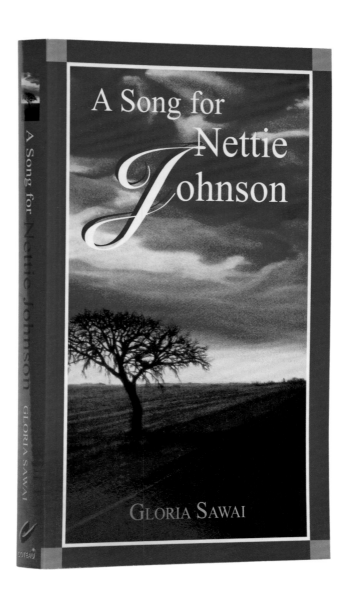

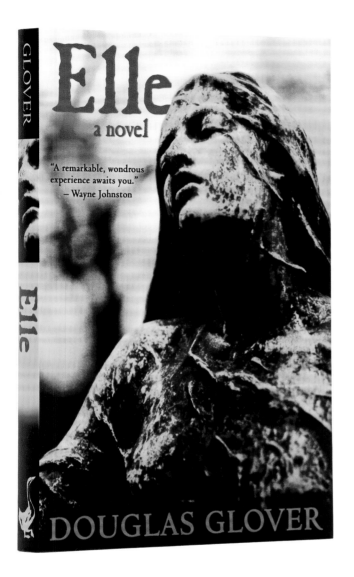

[ONTARIO]

Glover, Douglas

Elle

Fredericton: Goose Lane Editions, 2003
Published 21 April 2003 @ $21.95
Printed by Transcontinental
Cover design: Chris Tompkins
Photograph: Mel Curtis / Getty Images
Signed

Toews, Miriam

A Complicated Kindness

Toronto: Alfred A. Knopf Canada, 2004
Published 20 April 2004 @ $29.95
Printed by Berryville Graphics, Berryville, Virginia
Jacket design: Kelly Hill
Signed

2004

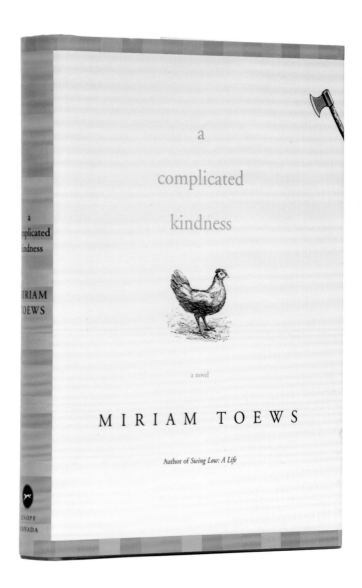

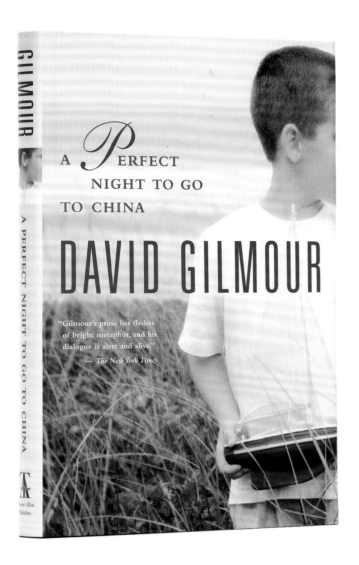

[ONTARIO]

Gilmour, David

A Perfect Night to Go to China

Toronto: Thomas Allen Publishers, 2005
Published 26 March 2005 @ $26.95
Printed by Friesens, Altona, Manitoba
Jacket design: Gordon Robertson
Photograph: Peter Urbanski
Signed

[QUEBEC]

Behrens, Peter

The Law of Dreams

Toronto: House of Anansi Press Inc., 2006
Published August 2006 @ $32.95
Printed by R.R. Donnelly, Harrisonburg, Virginia
Jacket design: Carol Devine Carson
Photograph: Metropolitan Museum of Art
Signed

2006

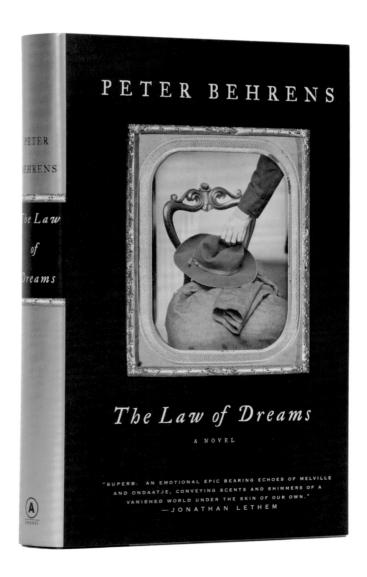

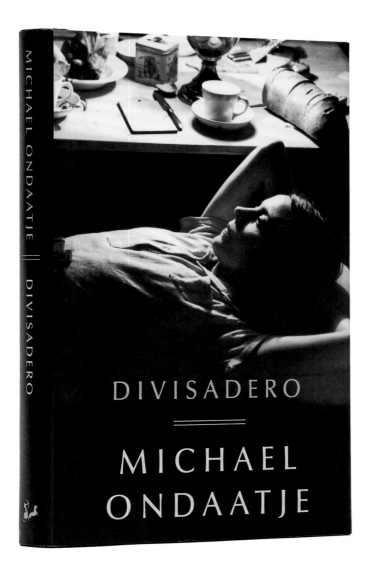

[ONTARIO]
Ondaatje, Michael
Divisadero

Toronto: McClelland and Stewart, 2007
Published 17 April 2007 @ $34.99
Printed by Friesens, Altona, Manitoba
Jacket design: Carol Devine Carson
Photograph: Willy Ronis / Rapho
Signed

[ONTARIO]

Ricci, Nino

Origin of Species

Toronto: Doubleday Canada, 2008
Published 30 September 2008 @ $34.95
Printed by Berryville Graphics, Berryville, Virginia
Jacket design: Kelly Hill
Photograph: David Madison / The Image Bank / Getty Images

2008

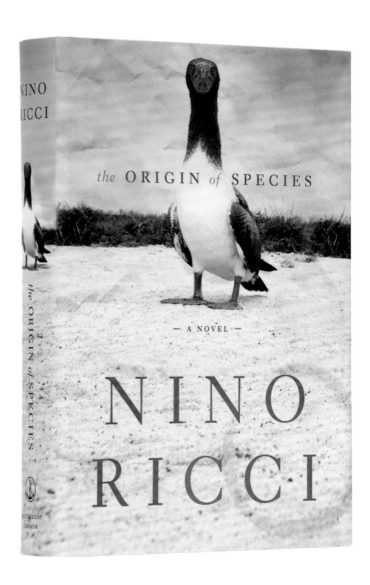

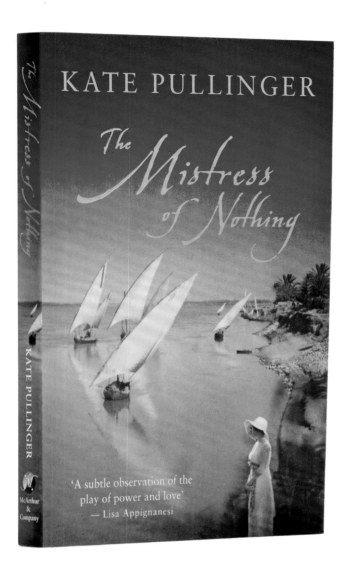

[BRITISH COLUMBIA]

Pullinger, Kate

The Mistress of Nothing

Toronto: McArthur & Company, 2009
Published 1 September 2009 @ $24.95
Printed by Webcom Limited, Toronto
Cover design: Peter Dyer
Image: Science & Society Library
Signed and dated 26 November 2009 at
 Rideau Hall, Ottawa

Glossary

ADVANCE REVIEW COPY: A printed copy of a new book sent to reviewers, chosen booksellers, judges of book clubs, etc. in advance of publication. Such copies are normally either final proofs or the first of the main run.

ASSOCIATION COPY: A copy which once belonged to, or was annotated by, the author, or belonged to someone connected with the author or someone of interest in his or her own right, or belonged to someone peculiarly associated with its contents.

AUTHOR COPY: A copy of a book the author wrote and personally owned. The author might use this copy for reading publicly or for editing a later edition. It is particularly coveted by collectors.

BINDING VARIANT: A general term for the variations of colour, fabric, lettering or decoration between different copies of the same edition of a book bound in publisher's cloth.

DEDICATION COPY: It is customary for an author to present an early copy to the person (if any) to whom it is dedicated. The dedication copy ranks very high in the estimation of most collectors.

ENDPAPERS: Double leaves are added at front and back by the binder; the outer leaf of each is pasted to the inner surface of the cover, while the inner leaves (or free endpapers) form the first and last of the volume when bound.

FIRST EDITION, FIRST IMPRESSION, FIRST ISSUE, FIRST PRINTING: These terms mean the first appearance of the work, independently, between its own covers.

GALLEYS: Early proofs are pulled on long strips. They contain any printer's errors and misprints. Some carry marginal corrections by the author.

PERFECT BOUND: This type of thermoplastic binding uses a plastic solution rather than sewing to hold the leaves together.

PRESENTATION COPY: For books which win the Governor General's Literary Award, this is the copy, in a specially commissioned art binding, which is presented to the author by the Governor General.

PROOFS: First proofs of a book are provided by the printer for the author's correction and the publisher's scrutiny. Revised proofs are the intermediate stage either to final proofs or to the finished book.

REVIEW COPY: Review copies, sent out to reviewers after the official publication date, are either stamped as such or have a printed slip loosely inserted, possibly with other information or material such as the retail price, publication date, first print run, early reviews, promotional plans, or an author photograph.

TRADE EDITION: An edition of a book published for distribution to the general public through booksellers.

These descriptions are largely excerpted from John Carter's classic ABC for Book Collectors, *revised by Nicolas Barker, 6th ed. (London: Granada, 1980). Please refer to Carter for more elaborate descriptions of the terms used in this catalogue.*